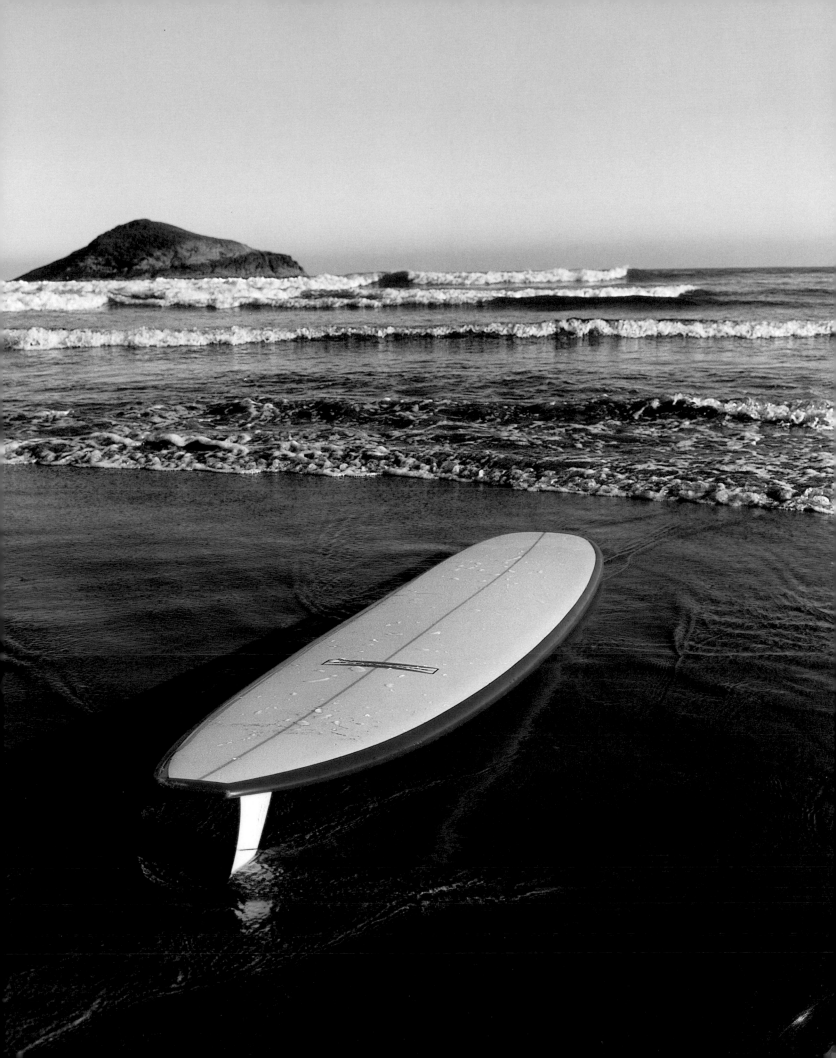

BAJA
TO
VAN
COU
VER

THE WEST COAST AND
CONTEMPORARY ART

wattis
CCA Wattis Institute
for Contemporary Arts

MUSEUM OF
CONTEMPORARY ART
SAN DIEGO

SAM | seattle art museum
seattle asian art museum
olympic sculpture park

Vancouver
Artgallery

Baja to Vancouver: The West Coast and Contemporary Art has been organized by the CCA Wattis Institute for Contemporary Arts, Museum of Contemporary Art San Diego, Seattle Art Museum, and Vancouver Art Gallery.

Curators: Ralph Rugoff and Matthew Higgs, CCA Wattis Institute; Toby Kamps, Museum of Contemporary Art San Diego; Lisa Corrin, Seattle Art Museum; Daina Augaitis, Vancouver Art Gallery

Exhibition Schedule

SEATTLE ART MUSEUM
9 October 2003–4 January 2004

MUSEUM OF CONTEMPORARY ART SAN DIEGO
23 January–16 May 2004

VANCOUVER ART GALLERY
5 June–6 September 2004

CCA WATTIS INSTITUTE FOR CONTEMPORARY ARTS
6 October 2004–10 January 2005

This catalog is published in conjunction with the exhibition *Baja to Vancouver: The West Coast and Contemporary Art*.

Editor in Chief	Ralph Rugoff, CCA Wattis Institute
Editorial Director	Leigh Markopoulos, CCA Wattis Institute
Contributing Editor	Matthew Higgs, CCA Wattis Institute
Publication Manager	Erin Lampe, California College of the Arts
Copy Editor	Erica Olsen, California College of the Arts
Design	Judith Steedman, Steedman Design
Print Coordination	Uwe Kraus, International Book Production

ISBN: 0-9725080-2-3

Printed in Italy.
The text of this volume is set in Janson and Univers.
Canadian spelling has been retained in texts by Daina Augaitis and Lisa Robertson.

The exhibition tour of *Baja to Vancouver: The West Coast and Contemporary Art* has been generously supported by the Peter Norton Family Foundation and the Department of Foreign Affairs and International Trade of Canada. The exhibition catalog has received significant support from the Jumex Collection.

Department of Foreign Affairs and International Trade

Ministère des Affaires étrangères et du Commerce international

LA COLECCIÓN JUMEX.

Significant support for the CCA Wattis Institute for Contemporary Arts has been provided by Phyllis C. Wattis and Judith P. and William R. Timken. Additional generous support has been provided by Grants for the Arts/San Francisco Hotel Tax Fund.

The San Diego presentation of *Baja to Vancouver: The West Coast and Contemporary Art* is made possible by the generous contributions of MCASD's International Collectors. Additional support has been provided by an anonymous donor, the LEF Foundation, and the City of San Diego Commission for Arts and Culture.

Generous support in Seattle provided by PONCHO (Patrons of Northwest Civic, Cultural and Charitable Organizations), *The Seattle Times*, Microsoft, and the Seattle Art Museum Supporters (SAMS). Major support also provided by The Harris and the Cultural Development Authority of King County, with additional support provided by Contributors to the Annual Fund.

The Vancouver Art Gallery gratefully acknowledges the ongoing support of the City of Vancouver, the Province of British Columbia through the BC Arts Council, the Government of Canada through the Canada Council for the Arts and the Department of Canadian Heritage-Museum Assistance Program, and the Greater Vancouver Regional District, the Vancouver Arts Stabilization program, and the Gerald and Sheehan McGavin Capital Grants to the Arts. We also gratefully acknowledge the Department of Foreign Affairs and International Trade of Canada and the Canada Council for the Arts Visiting Foreign Artists Program for their support of this project.

Cover	Marcos Ramírez ERRE *Crossroads (Tijuana/San Diego)*, 2003
p. 1	Shannon Oksanen & Scott Livingstone *Vanishing Point* (production still), 2001
p. 2	Mark Mumford *We Are All in This Together*, 2002

CONTENTS

FOREWORD

Baja to Vancouver: The West Coast and Contemporary Art presents a revealing selection of recent art being made on the western edge of the United States, Canada, and Baja California, Mexico. The first in-depth museum exhibition of art from this transnational coast, it reflects on the shared social, historical, and topographical conditions that set this area apart from the rest of North America. Appropriately, this ambitious endeavor was undertaken as a joint project with institutions along the West Coast working together in an unprecedented collaboration.

Each member of the curatorial team—Matthew Higgs and Ralph Rugoff from the CCA Wattis Institute for Contemporary Arts, Toby Kamps from the Museum of Contemporary Art San Diego, Lisa Corrin from the Seattle Art Museum, and Daina Augaitis from the Vancouver Art Gallery—brought a distinct perspective and voice to the conceptualizing and organizing of this exhibition. The final shape of *Baja to Vancouver* grew out of an extensive research process for which these curators conducted literally hundreds of studio visits with artists in Tijuana, San Diego, Los Angeles, the San Francisco Bay Area, Portland, Seattle, and Vancouver. It also reflects the many dialogues in which the curators engaged over the course of lengthy group meetings in different West Coast cities.

Since its initial conception almost three years ago, *Baja to Vancouver* has been envisioned as an exhibition that would identify cultural threads of connection that unite and distinguish the art being made along this 2,200-mile-long coastal corridor. Yet while it explores contemporary art from a specific geographical area, *Baja to Vancouver* is hardly a "regional" exhibition in any conventional sense of that term. The diverse artistic community it examines is, in fact, among the most significant in the world. And by offering evidence of creative cross-talk and shared aesthetic concerns among artists living and working on North America's West Coast, this exhibition reveals the need to redefine our notions of "regional" art centers, expanding them beyond considerations of national identity.

As with any collaborative undertaking of this scale, many people have played a key role and deserve to be acknowledged. We are grateful to the Peter Norton Family Foundation and the Canadian Department of Foreign Affairs and International Trade for their generous support of the exhibition tour and to the Jumex Collection for their significant support of this publication. We are delighted that the lenders to this exhibition have entrusted our institutions with works from their collections and have so generously agreed to part with them for a substantial period of time so that they can be shared with a larger public. We also wish to thank the many outstanding contributors to this catalog, and its talented designer, Judith Steedman.

In addition to the curators of this exhibition, the staffs of each institution have performed with their usual combination of inventive resourcefulness and professional skill, fueled by a passion for the work of living artists. California College of the Arts would like to acknowledge the inspired work of Susan Avila, Vice President for Advancement; Kathleen Butler, Associate Vice President for Advancement; Lisa Kitchen, Foundation, Corporate, and Government Giving Manager; Chris Bliss, Vice President for Communications; Kim Lessard, Publicity and Promotions Manager; and Valerie Imus, Curatorial Associate. Erin Lampe, Director of Publications, and Erica Olsen, Copy Editor, along with the Wattis Institute's Deputy Director Leigh Markopoulos, deserve a special thank you for the remarkable commitment and professionalism they brought to overseeing the editing, production, and design of this book.

At MCASD, nearly every staff member had a hand in realizing this project. In the curatorial department, Tracy Steel, Curatorial Coordinator, and Joanne Leese, Curatorial Assistant, oversaw countless logistical matters. Registrar Mary Johnson and Registrarial Assistant Meghan McQuaide Reiff supervised consolidation of regional works and shipping and handling. Chief Preparator Ame Parsley and Preparator Dustin Gilmore, along with Production Manager Mike Scheer, ably coordinated the installation in our galleries. Anne Farrell, Director of External Affairs, and Jane Rice, Director of Institutional Advancement, along with Verónica Lombrozo, Grants Officer; Synthia Malina, Annual Giving Manager; and Jennifer Reed Rexroad, Corporate Partnerships Officer, spearheaded fundraising initiatives. Charles Castle, Deputy Director, and Trulette Clayes, Controller, handled contracts and administration. Bryan Spevak, Public Relations and Marketing Officer, and Laurie Chambliss, Public Relations and Marketing Coordinator, publicized the project locally and nationally.

The Seattle Art Museum wishes to express its gratitude to Tara Young, former Assistant Curator of Modern and Contemporary Art; Susan Bartlett, Exhibitions and Collections Coordinator; Zora Hutlova Foy, Manager of Exhibitions and Curatorial Publications; Michael McCafferty, Chief Exhibition Designer; Dianne Simmonds, Senior Assistant Registrar; Jill Rullkoetter, Director of Education; Laura Bales, Corporate Relations Manager; Laura Hopkins, Foundations Relations Officer; Christina dePaolo, Information Technology Manager; and Jamie Andrews, Audio/Visual Services Manager.

The Vancouver Art Gallery would like to thank its staff from the Development Department for taking the lead on fundraising; Diane Robinson, Head of Marketing, and Marketing Department staff for their initiatives in international advertising and coordination of the public relations effort; Jacqueline Gijssen, Head of Museum Services, for contract negotiations; Melanie O'Brian, Assistant Curator, and Angela Mah, Administrative Assistant, for curatorial support; Wade Thomas, Audio Visual Technician, for coordinating the audiovisual needs of the tour; and Tom Meighan, Visitor Services Manager, for leading the staff team in mounting the exhibition in Vancouver.

MICHAEL S. ROTH
President
California College of the Arts

MIMI GATES
Director
Seattle Art Museum

HUGH M. DAVIES
The David C. Copley Director
Museum of Contemporary Art
San Diego

KATHLEEN S. BARTELS
Director
Vancouver Art Gallery

ACKNOWLEDGMENTS

Baja to Vancouver: The West Coast and Contemporary Art has been a lengthy and complex undertaking, and like any project of this scale it could not have been realized without the help of many people. As curators of the exhibition, we wish to thank the numerous individuals outside our respective institutions who assisted us during the process of researching this exhibition and producing this catalog:

In Los Angeles: Shoshona Blank, Tim Blum, Wendy Brandow, Brian Butler, Mary Dean, Marc Foxx, Mary Goldman, Robert Gunderman, Rodney Hill, Ciara Innes, Margo Leavin, David McAuliffe, Kimberli Meyer, Patrick Painter, Jeff Poe, Ed Ruscha, Randy Sommer, Richard Telles, Mayo Thompson, Sachiyo Yoshimoto, Corrina H. Wright.

In San Diego: Stephanie Hanor, Betti-Sue Hertz, Rubén Ortiz-Torres, Mark Quint, Marcos Ramírez ERRE, Rachel Teagle, Perry Vasquez.

In San Francisco: Paule Anglim, Frish Brandt, Rena Bransten, Ed Gilbert, Cheryl Haines, Jack Hanley, Connie and Steven Wirtz.

In Seattle and Portland: Robert Adams, Elizabeth Brown, Esther Claypool, Ben and Aileen Crohn, Pulliam Deffenbaugh Gallery, Linda Farris, Froelick Gallery, Jerry Garcia, Randy Gragg, James Harris, Gary Hill, Linda Hodges, Stuart Horodner, Billy Howard, Matthew Kangas, Greg Kucera, John Laursen, Elizabeth Leach, Pamela Meredith, Noodle Works Space, PDX Gallery, Tracy Savage, Francine Seders, Rebecca and Zandy Stewart, Bill and Ruth True, Merrill Wright.

In Vancouver: Ilana Aloni, Arabella Campbell, Monte Clark, Sydney Hermant, Catriona Jeffries, Tracey Lawrence and Chris Keetley, Christina Ritchie, Reid Shier, Andy Sylvester, Jeff Wall, Scott Watson.

And in New York: Catherine Belloway, Chana Budgazad, Haan Chau, Marian Goodman, Casey Kaplan, Laura Mackall, Robert McKeever.

We also owe considerable thanks to the contributing writers, Douglas Coupland, Lisa Robertson, and Matthew Stadler, as well as to Torolab and the Center for Land Use Interpretation, for their invaluable and distinctive contributions to this catalog. Judith Steedman deserves kudos, meanwhile, for her innovative and elegant design of this publication.

To all of the talented artists who generously spent time with us during the research phase of this project, welcoming us into their studios or showing us documentation of their work, we extend our deep appreciation and gratitude.

Finally, we give our heartfelt thanks to the artists featured in *Baja to Vancouver*—for making such excellent and thoughtful work, and for participating in the exhibition.

DAINA AUGAITIS, LISA CORRIN, MATTHEW HIGGS, TOBY KAMPS, AND RALPH RUGOFF

8

LENDERS

Michael Brophy

Delia Brown

Roman de Salvo

Sam Durant

Kota Ezawa

Harrell Fletcher & Miranda July

Chris Johanson

Tim Lee

Ken Lum

Matt McCormick

Roy McMakin & Domestic Furniture

Mark Mumford

Shannon Oksanen & Scott Livingstone

Michele O'Marah

Glenn Rudolph

Steven Shearer

Larry Sultan

Catherine Sullivan

Ron Terada

Althea Thauberger

Torolab

Yvonne Venegas

Jacky Ilana Allalouf
Michael Audain & Yoshiko Karasawa
Kathleen & Laing Brown
Rena Conti & Ivan Moskowitz
Christos & Sophie Dikeakos
Marilyn & Larry Fields
Bernardo Nadal Ginard
Jack Hanley
Sara Ephraim Kier
Marcia Goldenfeld Maiten & Barry Maiten
Godfrey McLaughlin
Jill & Dennis Roach
William & Ruth True
Dean Valentine & Amy Adelson

Blum & Poe, Los Angeles
D'Amelio Terras Gallery, New York
Marc Foxx, Los Angeles
Mary Goldman Gallery, Los Angeles
Haines Gallery, San Francisco
Jack Hanley Gallery, San Francisco
James Harris Gallery, Seattle
Catriona Jeffries Gallery, Vancouver
Casey Kaplan, New York
Tracey Lawrence Gallery, Vancouver
Museum of Contemporary Art San Diego
National Gallery of Canada, Ottawa
Quint Contemporary Art, La Jolla
Andrea Rosen Gallery, New York
Richard Telles Fine Art, Los Angeles
Vancouver Art Gallery
Shoshana Wayne Gallery, Santa Monica
Stephen Wirtz Gallery, San Francisco

And those collectors who wish to remain anonymous.

ESSAYS

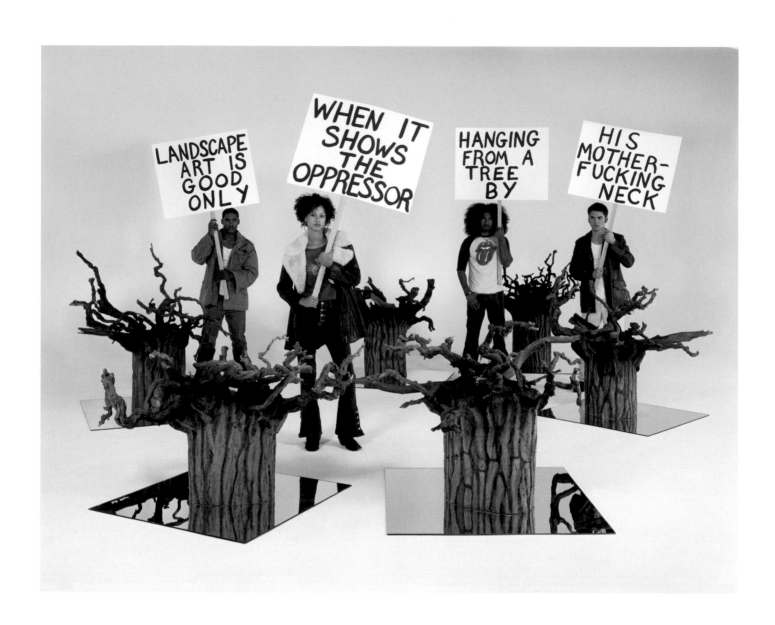

RALPH RUGOFF

BAJA TO VANCOUVER

THE WEST COAST AND CONTEMPORARY ART

To my knowledge, no existing bus or train routes run directly from Baja California to British Columbia. The trail from Tijuana to Vancouver is neither an important trade route nor a key geographic avenue of immigration. On the maps of our popular imagination, meanwhile, this coastal corridor boasts no particular histories or distinguishing traditions that unite it. Yet this exhibition grew out of a shared conviction that the West Coast from Baja to Vancouver deserves consideration as a distinctive cultural terrain. And that, as such, it is arguably North America's most vital region of contemporary art making.

The grounds for this latter contention have evolved only over the last few years. During the past decade both Los Angeles and Vancouver have received increasing international recognition for their significant and sizeable contemporary art scenes. (Each of these scenes has already been the subject, for example, of extensive survey exhibitions organized by European institutions.)[1] Yet it is only relatively recently that a diverse community of contemporary artists has emerged in the Tijuana/San Diego area. That development, along with our appreciation of work by younger and/or overlooked artists living in the Pacific Northwest and Northern California, became a tipping point in our formulation of this exhibition.

A larger consideration underlying this exhibition is the question whether there is a compelling reason to link artists living in cities as different as Los Angeles and Seattle or Portland, Tijuana and the San Francisco Bay Area, San Diego and Vancouver. Does this over-two-thousand-mile-long transnational corridor truly constitute a coherent region? Clearly, crucial social, economic, and historical differences distinguish these West Coast cities, yet even a brief examination reveals some telling similarities. Relative latecomers in the history of urban development and North American settlement, they were all incorporated in the second half of the nineteenth century. The geographical location of these cities at the continent's western edge helped foster in their citizens a sense of remove from the traditions and social conventions of their respective nations, as well as from the influence of Europe. Seemingly distanced from the burdens of history and liberated by their relative isolation, West Coast cities early on were mythologized as places where dreams could be realized

Left: Sam Durant, *Landscape Art (Emory Douglas)*, 2002

and selves reinvented. Their local cultures evolved around frontier values of individualism and innovation, as well as a hedonistic impulse that shaped, among other things, the West Coast's more experimental manifestations of modernist architecture. This hybrid ethos still fuels the unconventional design ethic (whether applied to computers, software, or buildings) as well as the many novel youth and pop cultures that flourish on the West Coast today.

These coastal cities are also distinguished by their dramatic natural settings. As a consequence, almost all of them have developed significant tourism industries, as well as elaborate recreational and leisure cultures. Whether it is the Pacific Ocean or nearby mountains, the presence of nature is indelibly integrated into each city's self-image and is continually propagated in tourism advertising and mass media imagery. In sharp contrast to most of their East Coast and European counterparts, West Coast cities are also defined by a mixed topography that is partly urban, partly suburban, and partly rural. They are places where streetscape and landscape often seem to merge, blurring conventional boundaries between natural and man-made environments and underscoring the apparent arbitrariness of city limits. On the other hand, the natural settings of these cities can sometimes seem slightly uncanny, as if they were no more than theatrical backdrops on the soundstage of urban life.

Of course, none of these similarities ensures that the contemporary art produced in West Coast cities will necessarily display common characteristics. The relationship between art and locale is a tenuous one, especially at a moment when the geography of contemporary art is increasingly international, and when new information channels make it easier than ever for artists to learn of and develop dialogues with art made in distant places. And there have always been artists whose

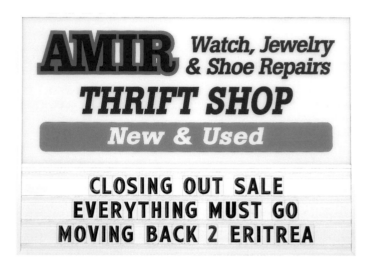

work, at least on the surface, seems to bear little or no relation to where it is made.

Baja to Vancouver, however, specifically focuses on representational artworks, many of which engage with the myriad social landscapes of this region. As curators, we have not sought to pinpoint a visual aesthetic or conceptual methodology that would somehow identify a "brand" of West Coast art. Indeed, the works featured in this exhibition display a remarkable range of approaches. They tend to recycle popular genres and forms—landscape and portraiture, vernacular signage and music videos—but where one work might engage with forms of urban folk art, another twists the visual rhetorics of advertising and Hollywood, and yet another revisits conventions of documentary photography. The artists in this show make use of a broad spectrum of media as well—including the Internet, painting, drawing, photography, sculpture, video, film, and installation—but do so in ways that are not fundamentally different from how artists work in other parts of the world. The aesthetic and conceptual strategies embodied in these works are an international currency, not a local one.

These strategies are applied, however, to subjects that are often especially pertinent to, characteristic of, or

Above: Ken Lum, *Amir New and Used*, 2000

resonant with specific social landscapes of the West Coast. Thus Brian Jungen's masklike sculptures reinterpret and recontextualize icons of British Columbia's First Nations tribes, while Brian Calvin's paintings revisit the contemporary youth tribes of Los Angeles. Some works in *Baja to Vancouver* conjure the difficult lives of recent immigrants to the region, as do Ken Lum's jarring takes on small business and store signs, which convey unexpectedly personal messages related to racism and global traumas. Others, including photographs by Yvonne Venegas and Larry Sultan, critically examine visions of the "good life"—whether in the homes of newlywed brides from Tijuana's nascent middle class or in homes rented out as sets for pornographic movies in L.A.'s San Fernando Valley. Still other works address the region's changing topographies: the depredation of old-growth forests; the coastal shoreline's transformation into industrial and military staging grounds; or the increasing sprawl of cities whose lights, as Russell Crotty's drawings of the night sky remind us, cast a disconcerting glow into wilderness areas.

For all the aesthetic variety encompassed within this exhibition, several distinct motifs and strands of interest weave in and out of the array of artworks that it presents. Most of the pieces, for instance, engage with forms of pop culture in a manner that is often simultaneously skeptical and appreciative. A number of artists from Los Angeles and Vancouver, in particular, contribute works that respond to the conspicuous presence of the film and television industries based in those cities. Stan Douglas's Cinemascope-proportioned photograph of a derelict Vancouver street employs cinematic tropes of lighting and scale, while Liz Magor's trompe l'oeil sculptures evince the eerie theatricality of movie props and Michele O'Marah's video work—a deliberately amateurish remake and genre pastiche—critically dismantles the "naturalism" of Hollywood films.

Pop music provides another arena of interest for West Coast artists (as it does, admittedly, for artists in other parts of the world). Delia Brown, Tim Lee, and Althea Thauberger reinterpret the music video format in works that, among other things, subtly question representations of class, ethnicity, and gender in pop culture. Works by Steven Shearer, Trisha Donnelly, and Evan Holloway, meanwhile, address the gestural rhetoric and iconography of rock and roll, especially as it is elaborated from the perspective of fans.

Given the less traditional and less formal demeanor of West Coast culture in general, it is perhaps no surprise that, for many artists in this region, pop media constitute a local vernacular. But for most of these artists pop culture is not so much the content of their art as a conceptual filter. When their works recycle pop idioms and artifacts, it is often in order to explore issues related to translation and representation, rather than to celebrate or critically reevaluate their source material. This is as true of Catherine Sullivan's *Little Hunt*, 2002, which filters actions like shooting a gun or dancing a reel through a variety of theatrical acting tropes, as it is of Lee's video installation, which transforms a raucous Beastie Boys rap into a dryly inflected Asian-Canadian solo act. In the process, these artists reveal the contingent meanings of specific cultural codes and dialects, as well as their ideological underpinnings, by refiguring them and/or organizing them around figures of cultural difference. This same strategy informs Kota Ezawa's brief yet powerful video, *The Simpson Verdict*, 2002, which translates news footage into an animated forensic drama where stripped-down gestures and facial tics take on a heightened and haunting charge. Translation also shapes the practice of designer and artist Roy McMakin, who

reconfigures codes of modernist sculpture and painting into pieces of functional furniture, and vice versa.

The practice of making representational art that engages with the problematics of representation can hardly be considered the exclusive property of West Coast art, yet it certainly has a formidable lineage here. Jeff Wall's photographic translations of historical paintings have had an impact on the thinking of many artists in Vancouver and elsewhere. And it is tempting to go further back in contemporary art history and invoke the influence of Ed Ruscha, arguably the first West Coast artist (much as Andy Warhol is arguably the first

double-edged, one-line texts or Roman de Salvo's wry homage to historical symbols of the West, one senses an echo of Ruscha's droll problematizing of representational codes—his quiet insistence that every image is a translation of preexisting standards and norms.

While *Baja to Vancouver* has no dominant theme, much of the art—including many of the works cited above—

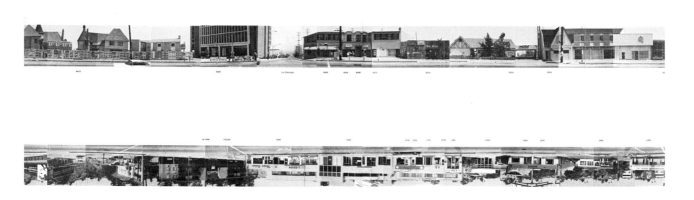

American artist). Indeed, Ruscha's art—with its references to cinema, billboards, and roadside signs, its rhetorical uses of Western landscape imagery, and its wry conviction that no picture is innocent—encompasses a sizeable piece of the terrain covered by the artists in *Baja to Vancouver*. His seminal artist's books from the 1960s, it is worth noting, inspired members of Vancouver's photo-conceptual school, including Stan Douglas (whose photograph *Every Building on 100 West Hastings*, 2001, directly recalls the title of Ruscha's 1966 book, *Every Building on the Sunset Strip*). And in the documentary deadpan of filmmaker Matt McCormick or the Center for Land Use Interpretation, in Mark Mumford's

revolves in one way or another around a critical thematic axis. The two poles of this axis are an obdurate individualism and a longing for the communal. These poles comprise the foundational contradiction of the West Coast mythos: its double identity as a region given over to the free play of individualistic frontier values and as an arcadian site of (potential) social utopias. Historically, people have been drawn to West Coast communities not only in hopes of reinventing themselves, but also of reinventing society; indeed, there is an extensive history of communes and idealistic collectives on the West Coast dating back to the early twentieth century.

On one hand, then, *Baja to Vancouver* invites viewers to reflect on the alienated slackers, backwoods loners, and self-absorbed romantics depicted in works by, respectively, painter Brian Calvin, photographer Glenn Rudolph, and film/video maker Althea Thauberger. Isolated against a background of the West Coast's

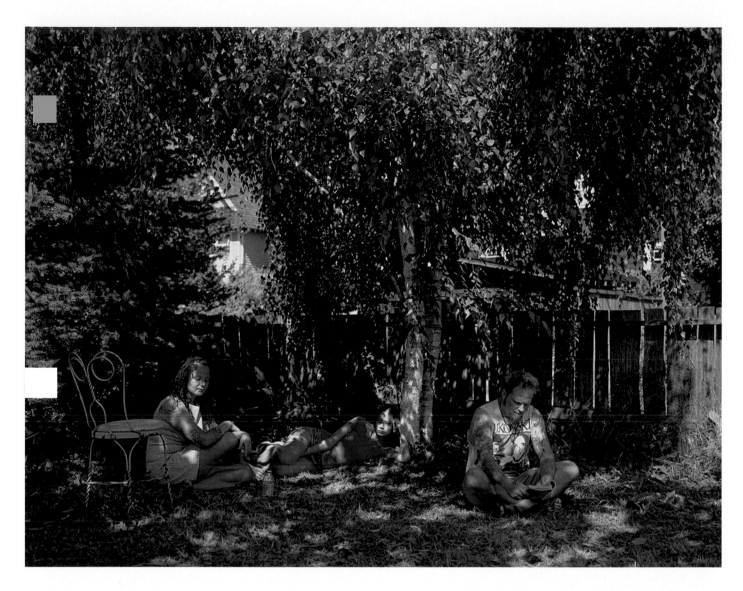

majestic terrain, these figures appear to be trapped inside their own solitary lives, isolated by their hermetic values and behavior.

On the other hand, utopian impulses animate many of the projects by the design team Torolab, whose proposed solutions to social problems in Tijuana comprise an idealistic pragmatism. They are evident as well in Harrell Fletcher and Miranda July's website, learningtoloveyoumore.com, which invites its visitors to

find simple ways of reaching out to their communities. And with a measure of barely discernible irony, they are given a spin in Delia Brown's *Pastorale*, 2002, a music video depicting a racially integrated yet airlessly idyllic vision of a Hollywood Hills utopia. Sam Durant's studio portraits of young models carrying generic protest signs, meanwhile, look askance at the revolutionary utopianism of the 1960s, prompting us to wonder whether the legacy of West Coast hippies and radicals can be reduced to a fashion statement.

The notion of utopia is, of course, inevitably accompanied by its opposite. Providing a recurring refrain in this exhibition, several artists invoke dystopic scenes and histories, drawing our attention to the troubles in

Above: Jeff Wall, *Tattoos and Shadows*, 1999
Cibachrome transparency, 54⅝″ x 108″ x 11⅞″
Courtesy the artist and Marian Goodman Gallery, New York. © Jeff Wall

Left: Ed Ruscha, *Every Building on the Sunset Strip* (detail), 1966
Courtesy the artist and Gagosian Gallery. © Ed Ruscha

paradise. Douglas's monumental photograph of West Hastings Street memorializes the failed promise of urban renewal, while Ezawa's *Simpson Verdict* commemorates a defining moment in Los Angeles's history of racial divisiveness (and one which cast a shadow over the upper-class Eden of Simpson's Brentwood neighborhood). In alluding to the pillaging of western forests, both Chris Johanson's caustically folky installation and Michael Brophy's paintings of desolate log cabin interiors invite us to wonder—and perhaps to feel shock—at the results of human folly and greed. Conjuring a more general sense of malaise and melancholy, Shannon Oksanen and Scott Livingstone's film depicting a riderless surfboard being knocked about by the waves suggests a fall from grace—a collective loss of the innocence and idealism associated with youth cultures in the 1960s. Operating on a more formal level, Thomas Eggerer's paintings—which depict groups engaged in outdoor leisure activities—evoke a simpler and safer era, yet by embedding their subjects in ambiguous spatial fields these works undercut our nostalgia and instead suggest a sense of social dislocation and confusion about place.

Yet even when artists in this exhibition address disturbing matters, their work remains deceptively casual in appearance. Much of the art in *Baja to Vancouver* evinces an off-kilter flatness, at times even seeming to flirt with banality. The visual sophistication of this work is not always superficially apparent, especially as it tends to mimic the distilled and disciplined economy of pop formats. And in pointedly reformulating familiar idioms, much of this art employs a low-key conceptualism that is rigorous without being abstract.

Two artworks sum up all these qualities to some extent and could serve as bookends for this exhibition, in a geographic as well as an iconographic sense. Marcos Ramírez ERRE's *Crossroads (Tijuana/San Diego)*, 2003, a

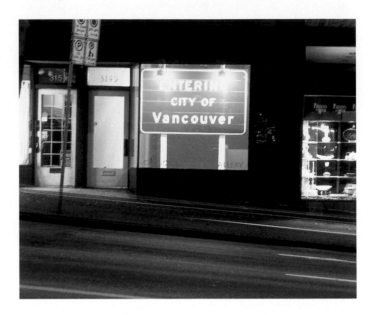

roadside marker with ten arrowlike arms indicating the way to different West Coast and international cities, addresses us as though we were setting off on a journey. In contrast, Ron Terada's 2002 replica of a highway sign, *Entering City of Vancouver*, conjures a moment of arrival. Evoking, respectively, positions of margin and hub, each work plays off local cultural dialogues and purviews. As a pair, they seemingly constitute a study in difference, indexing the diverse aesthetic range represented in *Baja to Vancouver*. Yet at the same time these two sign works create a kind of common conversational arena, as both question the relationship between art and locale while casting a skeptical eye on the ways and means by which we define place. These are concerns, needless to say, of particular relevance to an exhibition such as this one.

Recontextualized in gallery spaces, Terada's precisely manufactured facsimile appears as a denatured object—not a sign, but a representation of a sign. Stripped of its original function, its simple declaration is rendered meaningless, opening the way for other meanings to emerge. When first exhibited at Catriona Jeffries Gallery

Above: Ron Terada, *Entering City of Vancouver*, 2002

in Vancouver, Terada's sign seemingly poked fun at the way Vancouver artists are often identified, for purposes of commerce and publicity, in terms of a regional brand. (A recent article on Jeffries in *Canadian Art* asserted: "When you collect one of her artists—say, a Ron Terada or a Damian Moppett—you are ostensibly 'collecting Vancouver.'"[2]) On another level, Terada's uncannily displaced sign registers an apparent confusion about urban boundaries, indirectly invoking the difficulty of definitively representing Vancouver's—or any city's—cultural identity.

Compared to Terada's monolithic sign, Ramírez's colorful, multidirectional marker calls to mind a third world artifact. Pointing the way to wealthier West Coast and European cities, it engineers a semantic shift by reorienting Tijuana as a center in relation to which these other places are defined. In addition to listing a city, each directional arm bears a quotation from an artist from that city. Yet the relationship between artist's statement and location appears, in most cases, to be highly arbitrary, as if underscoring the absurdity of trying to define art strictly in terms of geography. Ultimately, *Crossroads (Tijuana/San Diego)* asks how cities function as specific cultural landscapes, and how—or under what conditions—artists living in different places address different audiences as well as one another.

In a sense, *Baja to Vancouver* explores the distance between these two signs as well as their common ground. It aims to highlight the way such works problematize clichés about regional identity; indeed, in bringing together art from the disparate cities and cultures of the West Coast, this exhibition likewise endeavors to undermine existing notions of the regional. There is a long history on the West Coast of city-defined regionalism (major museums in Vancouver, San Francisco, and Los Angeles, for instance, regularly organize survey exhibitions showcasing local artists). By moving beyond the limiting dichotomy of international and local, *Baja to Vancouver* suggests a more expansive way of demarcating zones of cultural production. And by providing a framework in which their points of connection might be made more visible, this exhibition also aspires to initiate new dialogues between the artists and cultures on North America's West Coast.

As mentioned earlier, our intention as curators has never been to delineate a particular West Coast aesthetic, nor to downplay the differences between the various places and artists represented in this exhibition. Instead, we have tried to assemble artworks that, through their overlapping concerns and sensibilities, provoke us to reimagine the ways that specific social landscapes can be understood through the visual arts. Finally, it is our hope that this exhibition will appear to its visitors to be a road trip worth taking—the kind of journey that transforms the manner in which we see the places and cultures around us.

1
Sunshine and Noir: L.A. Art 1960–1997 was organized in 1997 by the Louisiana Museum of Modern Art in Humlebaek, Denmark. *Hammertown: Eight Artists from Canada's West Coast* was organized in 2002 by The Fruitmarket Gallery in Edinburgh, Scotland.

2
Si Si Penaloza, "She's the One," *Canadian Art* (Spring 2003): 78–83.

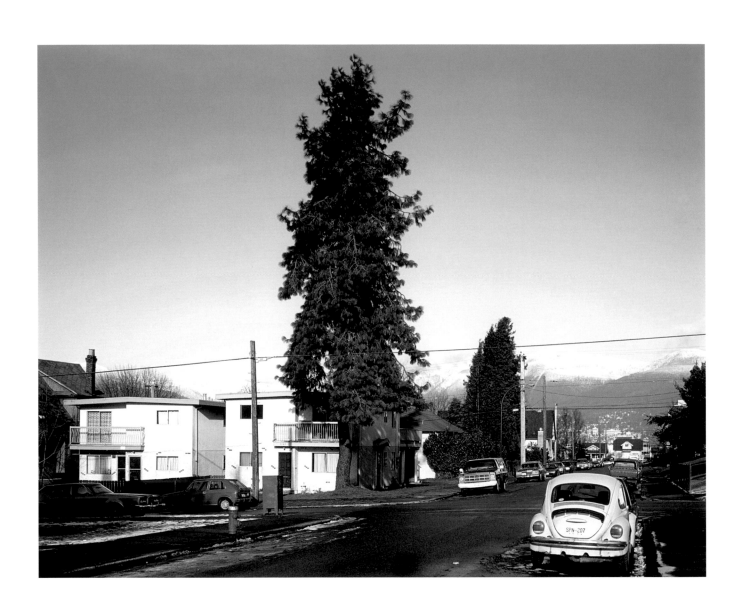

DOUGLAS COUPLAND

UNDER THE BIG BLACK SUN

I've flown between Vancouver and Los Angeles maybe forty or fifty times. Before September 11, 2001, all I had to do was ask, and the pilots would let me into the cockpit for a look. This was strange for a number of reasons. First, you're so close to the jet's nose that there's nothing between you and the planet. Even a car's hood affords more of a sense of vehicularity—it feels as if you're floating in the sky. Second, everything down below is so … big—big and largely uninhabited: you can see the planet's curvature, and starting with Mount Shasta, you can see a necklace of volcanoes one by one, right up through Oregon and into Washington and British Columbia. For much of the flight, logging roads and clear-cuts offer the only evidence of human interference in the landscape. Lastly, you realize that the cities of the

West Coast have more in common than not. San Diego, Los Angeles, San Francisco, Portland, Seattle, and Vancouver are each, in their own way, isomers of each other—ends of the line, buffered from the rest of the continent by vast mountains, multiple time zones, and a disproportional lack of history. These cities existed in embryonic form before 1900, but each city's ultimate form and psychic texture was molded by the twentieth century's dominant inventions—the car, the jet, computers, space technology, new materials, defense contracting, and entertainment. Any of these cities without freeways, plywood, airports, TV stations, and personal and business computers isn't a possibility.

The West Coast cities also share, to various degrees, links to utopian conceits, a heightened sense of relationship to nature, the general New World belief in self-reinvention, and a faith in the modernist creed that progress through the above-mentioned technologies will lead to a better tomorrow. Yet what makes these cities distinct, let alone different from each other, is the way in which these founding myths and dreams are customized on a city-by-city basis by these said factors. From this, we discern that much of what we interpret as a city's personality is actually the friction generated between its founding myth and the city as it actually plays itself out in real life.

Vancouver, where I've spent the majority of my life, is Canada's official end of the line—"Terminal City"—the place where one goes to change one's name, face, religion, family structure, politics, sexuality, gender, and career. Easterners call the city "Lotus Land," a corny and dated epithet that alludes to its relatively mild climate and the Canadian hippie influx of the 1960s, back when the city was essentially monoracial, Anglophilic, and a

stepping-stone to a staggeringly vast and plunderable hinterland of raw nature. Curiously, of all the cities I've visited and lived in, Vancouver now most closely resembles Honolulu in its remoteness—Honolulu, the forgotten city of the Pacific—with its Asian-skewed racial breakdown, its mountainous landscape, its psychic distance from the rest of the continent—and also in its postmodernized economy based on entertainment, a dwindling reliance on agriculture, real estate flipping, and tax loophole exploitation. Vancouver, like Honolulu, exists as a haven to which the globally wealthy flee to avoid pollutions—ecological and psychic—generated by the outside world's economy.

Vancouver is also a city, like Los Angeles, familiar with the odd position of pretending to be some other city in order to generate commerce. A large number of Vancouver's art school grads enter the film industry (Vancouver is North America's second largest center of production) only to end up in set decoration, propping up the city to be Seattle, Denver, Portland, or some other (almost invariably American) city. I've seen Vancouver warehouses filled with *Seattle Post-Intelligencer* newspaper boxes and cases of Colorado license plates. Image manipulation is a very big and very real business, which, along with Vancouver's other postindustrial economic engine components, conflicts with its posited hippie/utopian/raw materials myth.

Seattle, on the other hand, is a gateway to the Klondike, to Alaska. As such, it forgoes its role as a complete end of the line. For much of the twentieth century, Seattle's chosen mode of transformation, economically and symbolically, has been technology—first Boeing aircraft production, and then the high-tech Microsoft-centric push of the 1990s. Since I grew up watching the U.S. news via cable on Seattle's ABC, NBC, and CBS affiliates, it became possible at an early

age, and on a personal level, to view Seattle's civic culture as one of irreconcilable clashes: nature versus the freeway; earthy garage band grit versus the bloodless world of tech. Seattle's gift to the world was an entire decade, really—the 1990s—the first half colored by middle-class disaffection in the form of grunge music, the second half speaking of the more pragmatic and worldly pursuit of wealth via technology. Both trends conflicted with the Klondike Ho! image the city's tourism brochures like to present. Are we rednecks or are we geeks? Curiously, Seattle and Vancouver, only two hours apart by car, have no sense of competition with each other. Of any pairings of cities in this essay, these two seem to me the most unlike, and they view each other as such. (San Diego, superficially quite different from Seattle, actually shares with it a defense-driven economy, an active port, and utopian aspirations.)

Moving south, we encounter Portland. Centered on the Columbia River, it is a smaller city, and in terms of global accessibility, it is the most isolated of the major West Coast cities. Portland experiences the least discord between its myth and its reality. Like San Francisco and Vancouver, Portland sentimentalizes both nature and the landscape—although this middle-class haven still relies heavily on the natural resource base of its surrounding landscape. In national polls of the Most Liveable City, Portland always comes in first or second, most likely because its remoteness has buffered it from societal blights suffered elsewhere. It is a good place to live, and the city would like to keep it that way. Portland doesn't actively seek out conflict, and its politics tend to be conciliatory rather than confrontational. Its artistic energies are disproportionately funneled into film and literature, and work from Portland can seem to an outsider to have come from a universe parallel to our own, one in which mid-twentieth-century middle-class

agendas have essentially succeeded. It remains the most utopian of the West Coast cities.

And then there is San Francisco—the city that gave the world the 1960s, transuranium elements (via U.C. Berkeley and the Lawrence Livermore National Laboratory), digital technology, and sexual hypertolerance. It is a city in perpetual flux and constant reinvention. It is a difference generator. It seeks out and demarginalizes those on the fringes, ironically mainstreaming the sectors of society it intends to enhance and liberate. San Francisco is more politicized than most cities. Its creative work accepts and absorbs the tendency to foreground the marginal, while attempting to incorporate the fact that for much of the world, the city is a secular humanist Valhalla. Nikita Khrushchev once asked if residents had to pay a premium to live in the city. Technically the answer is no, but anybody who pays rent or a mortgage there would say yes. Almost against its will, the city embodies the future ten years hence. Even if it tried, it probably couldn't stop doing so.

San Francisco is an argumentative city. Nobody agrees with anyone else, on anything, and it is possible, as if in the London of yore, to find someone delivering a rant on every other downtown street corner. San Franciscans can also feel guilty about their epicurism and wonder if zoning laws meant to protect the look and texture of downtown life instead smother the possibility of creativity. The punch line is that it is this exact sort of self-flagellation and self-reflection that propels San Francisco further into the future.

Los Angeles is the one city of this bunch that has no real geographic reason to exist. Without the arrival of water at the start of the twentieth century or the manu-facturing of a harbor at Long Beach, Los Angeles would probably have ended up a seaside Flagstaff. But of course the water came, and the city wasn't so much built as assembled, a vast open-ended grid that for millions of Midwestern immigrants resembled a citrus-kissed paradise. And as Nathanael West noted in *The Day of the Locust*, people may well visit Glendale to watch the planes land or take off in hopes of a crash, but of course the planes never do. Life goes on, and a city goes on, too, not with plane crashes but with huge, globally televised catharses. While everybody was waiting for the planes to crash, the immigration and economic situations silently evolved.

If San Francisco is sentimental and willfully engaged in politics, Los Angeles is dispassionate and seemingly politically disengaged. The city is the world's sixteenth largest economy; the four-county region of Riverside, Los Angeles, Orange, and Ventura generates as much solid waste per year as the Indian subcontinent. And if San Francisco is a city that actively engineers earthly happiness, both socially and infrastructurally, Los Angeles, in contrast, searches more for the happiness of the socially atomized individual. While the middle class of San Francisco is a generally cheerful social caste, suburban Los Angeles is instead tinged with noir. To paraphrase Mike Davis, the prime social biographer of Los Angeles, noir is the artistic expression of the frustrated, disaffected, or defeated middle classes. The cinematic noir of the 1940s and 1950s portrayed the undeniable darkness of the city—a mood later evoked in the 1970s and 1980s by the quintessential Los Angeles punk band, X, with their album title *Under the Big Black Sun*.

Much of Los Angeles's cultural texture stems from the fact that while it still positions itself as a generator of newness, it is at the same time beginning to accrue a fair amount of history. All of this history is now on the cusp of choking the city's myth of self-reinvention and freedom from the past. Commercial buildings from as recently as the 1960s are now in their third or fourth, or

even ninth or tenth iterations as pet food huts, nail salons, Korean churches, and liquor stores. Off-tint rectangles smother the graffiti tags along city streets, metaphorically eclipsing expression from the underclass. It is a city that feels uncomfortable with aging in all its forms.

Finally, we have San Diego, the city most associated with the West Coast surf god myth. The city also bears the psychic residue, new and old, that accrues from being a military center, in terms of population base and defense contract production. San Diego's selling point has always been liveability; it is the city that dukes it out with Portland for the Most Liveable title. And yet, in recent decades, San Diego has begun to fuse, both psychically and developmentally, with Orange County. The civic lines have blurred. The spinach fields in Carlsbad have been replaced by Legoland; traffic gridlock can occur on the 405 at any time of day or night; the suburbs to the north of the city are haunted by the ghosts of native daughter Nicole Brown Simpson and the suicidal Heaven's Gate cult members in their Nike runners. Andy Warhol once said that women are at their most beautiful just before their nervous breakdown, and this aphorism might apply to San Diego. It is the city with the fuzziest founding myth, and the one currently undergoing the most cathartic demographic and labor-based shifts. Los Angeles and San Francisco are systematically adjusting to population shifts, whereas San Diego, close to the border, is undergoing demographic alchemy. Explain the myth of the surfer's perfect wave to a family of five smuggled into the harbor inside a Maersk shipping container with no light, fresh air, or food.

While I try to practice a form of critical distance from these cities, there are no other cities on the planet in which I could imagine living. Issey Miyake once said that the reason he kept designing new forms was that he had seen the remains of Nagasaki after the atomic bomb and saw nothing to be salvaged from a past that could willfully generate such madness. So he moved only forward. No such bombs for those like myself. Instead, there has been a constant erosion of ideas once considered either progressive or transcendental. On the West Coast, there is no other Past on which we can rely. There is only Whatever Comes Next, and this is what we believe in.

DOUGLAS COUPLAND is a Vancouver-based novelist and artist. His recent works with various European art establishments have begun to redraw the borderline between long-form fiction and critically based visual artwork. He is a contributor to the *New York Times* and *Artforum*.

Michael Brophy
Delia Brown
Brian Calvin
Russell Crotty
Roman de Salvo
Trisha Donnelly
Stan Douglas
Sam Durant
Thomas Eggerer
Kota Ezawa
Harrell Fletcher &
 Miranda July
Evan Holloway
Chris Johanson

ARTISTS

Brian Jungen
Tim Lee
Ken Lum
Liz Magor
Matt McCormick
Roy McMakin
Mark Mumford
Shannon Oksanen &
 Scott Livingstone
Michele O'Marah
Marcos Ramírez ERRE
Glenn Rudolph
Steven Shearer
Catherine Sullivan
Larry Sultan
Ron Terada
Althea Thauberger
Torolab
Yvonne Venegas

Michael Brophy

Throughout his career, Michael Brophy has referenced and manipulated authoritative pictorial traditions to construct critical overlooks onto the contemporary social landscape of the Northwest. The style of his oil paintings typically unites three pictorial traditions: Renaissance painting, with its rigorous compositions and atmospheric perspectives that create landscapes melting into distant horizons; the sweeping grandeur of nineteenth-century landscapes of the American West by artists such as Albert Bierstadt, Sanford Gifford, and Thomas Moran; and the blunt narratives and humble aesthetic of the American regionalism associated with 1930s social realists of the Works Progress Administration (WPA). The three traditions have in common their construction of landscape as a stage set where the social and the pastoral interact symbolically.

Many of Brophy's paintings of the Northwest landscape feature trompe l'oeil curtains pulled back to reveal the bald, arid hillsides that have taken the place of the virgin forests that once characterized the region. In *Forest Room*, 1999, Brophy presents a view out the windows of a log cabin, showing us not distant snowcapped peaks but raw clear-cuts. It is a pointed reminder that the rustic wooden dwellings we build to get "back to nature" are constructed from the last of the great trees that gave the Northwest its frontier identity. The charred cabin floor that Brophy depicts in *The Backroom*, 2002, mimics the shape of the windows, whose glass panes appear as no more than blank, serialized squares, suggesting that the scenic has given way to the symbolic.

As indicated by his ironic titles—*Pacific Wonderland, Cascadia,* and *Wooden Rome* are three recent works—Brophy is concerned with the transformation of landscape into myth, as exemplified by the nineteenth-century vision of the Northwest that lives on today in the public imagination. In his works, national forests are actually theme parks where, thanks to the logging industry, we are more likely to see tree stumps than Douglas firs, skyscraping electrical pylons than towering cedars.

Much of the power of Brophy's art comes from its intersection of the circumspect with the laconic. The artist may depict ravaged landscapes and barren mountainsides, but with down-home humor, he also populates these scenes with chain saw sculptures of hunters and grizzly bears—both equally endangered by logging. While Brophy represents these examples of roadside folk art in an equally folksy painting style, his brand of regionalism ultimately serves as a conduit to rigorous reflection on the relations between landscape and power in the Pacific Northwest. LISA CORRIN

Michael Brophy was born in Portland, Oregon, in 1960 and received a BFA from the Portland College of Art in 1985. He has had solo exhibitions at the Laura Russo Gallery, Portland (2001); Fields Art Center, Lewis and Clark College, Portland (2000); and Giustina Gallery, Oregon State University, Corvallis (1997). His work has been featured in numerous group shows including *Fallen Timber* (1994–5) and *Reshaping Traditions* (2003), both at the Tacoma Art Museum; the Oregon Biennial, Portland Art Museum (1991, 1997); and *The Garden Show*, Portland Institute for Contemporary Art (1997).

Portland

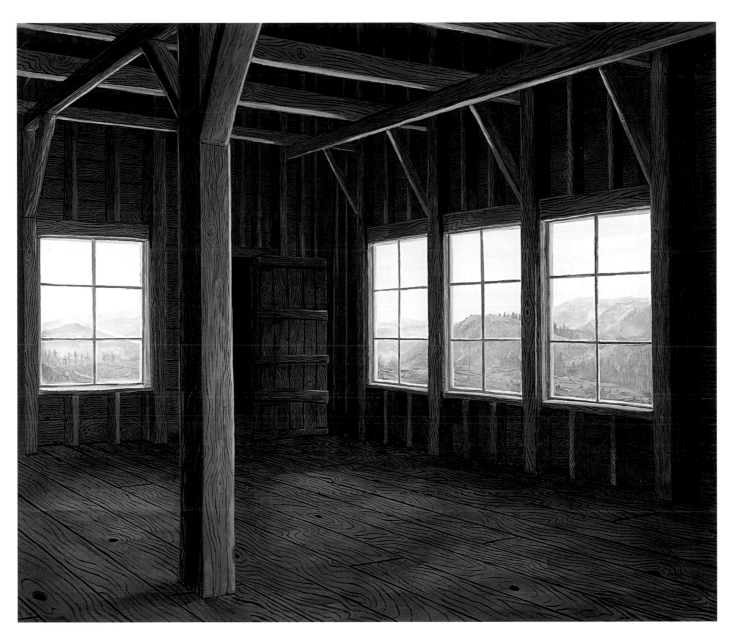

Michael Brophy
Forest Room, 1999

Delia Brown

Delia Brown's work is concerned with artifice. Through the agency of her drawings, watercolors, paintings, and her recent video *Pastorale*, 2002, Brown creates what might be thought of as "plausible fictions." Central to these fictive scenarios is the presence of the artist herself: acting the spurned lover or bored Hollywood rich kid, or pretending to be the daughter of her real-life Los Angeles dealer Margo Leavin. Like Cindy Sherman, who reimagined herself as the star of a succession of 1940s, 1950s, and 1960s B movies, or Kerri Scharlin, who had her daily life documented—and dramatized—by a professional courtroom artist, Brown pitches both herself and her works somewhere between fantasy and reality. Like Sherman and Scharlin, Brown restages herself through her adoption and subversion of mediated stereotypes: gendered abstractions of female identity lifted from the pages of fashion magazines or from the plots of daytime television dramas.

Approximating the form of a music video, *Pastorale* would appear to be ostensibly a promotional clip for its star, the Oakland-based soul diva Goapele, whose lush R 'n' B ballad "Closer" provides both the film's sound track and narrative drive. Shot by a professional crew on location in an idealized example of a California Craftsman house, *Pastorale* is in fact a highly mannered filmic tableau. The uniformly good-looking extras that populate Brown's film appear somewhat uncomfortable with their assigned roles. In their cool indifference—hanging out by the pool, tending the barbecue, or mooching around somewhat aimlessly—her troupe appear as if straight out of central casting. If the literary pastoral imagined the countryside through rose-tinted lenses, *Pastorale* reimagines suburbia as an unlikely rural idyll.

In their portrayal of a slightly vulgar, self-congratulatory, and somewhat decadent milieu, Brown's works are unsettling, their apparent lack of critical distance unnerving. It is appropriate that the artist both lives and works in the shadow of Hollywood, where artifice has long taken on the mantle of the real. Ultimately she seems most interested in creating confusion between the acknowledgment and identification of her own desires, and how those desires are subsequently negotiated and represented. Self-consciously engaged with the superficial, Brown's works might perhaps be best understood as a commentary on the nature of superficiality itself. Walking a thin line between parody and self-parody, the artist would appear to want to have her cake and eat it too. MATTHEW HIGGS

Delia Brown was born in 1969 in Berkeley, California. She received a BA from the University of California, Santa Cruz, in 1992 and an MFA from the University of California, Los Angeles, in 2000. Brown's solo exhibitions include *Forsaken Lover*, Il Capricorno, Venice (2002); *No Place Like Home*, Margo Leavin Gallery, Los Angeles (2001); and *What, Are You Jealous?*, D'Amelio Terras, New York (2000). Her work has also been presented in group shows such as the Prague Biennial (2003); *100 Artists See God*, Independent Curators Inc. (2003–4); and *Seeing*, LACMA Lab, Los Angeles County Museum of Art (2001).

Los Angeles

Delia Brown
Pastorale (still), 2002
(featuring Goapele)

Brian Calvin

Possessed by an almost comical inertia, the characters that populate Brian Calvin's paintings appear to be going nowhere fast. Beneath perennially blue Southern California skies, Calvin's motley tribe of introspective twentysomethings aimlessly go about their daily business: taking a hike, loitering at home or in the studio, playing the guitar, drinking beers, or smoking cigarettes. Set in picture-perfect coastal landscapes or in manicured suburban homes, Calvin's paintings chart—like Bret Easton Ellis's seminal 1985 Hollywood rite-of-passage novel *Less Than Zero*—the relentless ennui and rootless melancholy of disenfranchised youth in search of some form of distraction or enlightenment.

Painted in a deceptively nonchalant manner, Calvin's works are disarming. Their affected casualness—which echoes David Hockney's California paintings of the 1970s and Alex Katz's paintings of an East Coast middle class at play—belies their formal precision. In *Nowhere Boogie*, 2000, a young man peers expectantly through a window at the cartoonlike landscape beyond. Meanwhile, the androgynous figure that occupies the painting's foreground picks at an acoustic guitar, struggling to master the nihilistic blues of the painting's title. What distinguishes this seemingly banal and possibly vacuous scene is Calvin's almost fetishistic attention to the painting's detail: the barely registered modernist couch, the encroaching shade of a designer lamp, or the guitarist's illegible but semiotically charged T-shirt with its satanic metal overtones. In the sum of its parts, *Nowhere Boogie* comes to represent a precise analysis of suburban alienation, where the aspirational accessories of a lifestyle are baldly revealed as hollow signifiers.

Set outdoors in a graphically idealized landscape reminiscent of an animated backdrop, *California Freeform*, 2000, depicts yet more of Calvin's protagonists, this time at odds with nature. The central figure in the painting—divorced from his indoor sanctuary—tries to establish his bearings. Optimistically consulting a book titled *Telepathy* as if it were a map, he would appear to be on a fruitless quest. Behind him his companion, knee-deep in the inky blue waters of a lake and casually clutching a beer, appears unconcerned about his predicament. As in the more recent painting *Stream*, 2003—in which an obscured wader is frozen in the moment of removing a yellow top—nature is both regarded and depicted as somewhere to hang out in, or somewhere to get lost. MH

Brian Calvin was born in 1969 in Visalia, California. He received a BA from the University of California, Berkeley, in 1991 and an MFA from the School of the Art Institute of Chicago in 1994. Recent solo exhibitions of Calvin's work have been presented by Marc Foxx, Los Angeles (2003); Corvi-Mora, London (2002); and Gallery Side 2, Tokyo (2002). His work has also been shown in group exhibitions including *Painting Pictures: Painting and Media in the Digital Age*, Kunstmuseum Wolfsburg, Wolfsburg (2003); *Cher Peintre*, Centre Georges Pompidou, Paris (2002); and *the americans. new art*, Barbican Art Gallery, London (2001).

Los Angeles

Brian Calvin
Stream, 2003

Brian Calvin
Nowhere Boogie, 2000

Brian Calvin
California Freeform, 2000

Russell Crotty

A dedicated amateur astronomer, Russell Crotty has been studying and drawing the night skies for more than a decade. From the Solstice Peak observatory he built in the Santa Monica Mountains, as well as from other locations in Southern California, Crotty observes the planets, galaxies, and distant stars. Using the naked eye and a variety of portable telescopes, Crotty makes quick observational drawings on location using a red-filtered flashlight. In the studio, these sketches are translated into large, carefully detailed drawings, some presented in books or as single sheets, and others executed on plastic spheres.

The resulting ink-on-paper works recall the charts created by historic astronomers or nocturnal landscapes by the German Romantic painter Caspar David Friedrich, rather than technologically produced scientific images. Unlike these earlier images, however, Crotty's drawings often include representations of the local flora, buildings, and light pollution from nearby cities that frame his contemporary experience of stargazing. Neither mystifying nature nor reducing it to empirical data, his lovingly obsessive drawings are fueled by his conviction that photographs bleed the life out of celestial observation. (In this respect his approach differs from that of Vija Celmins, whose precise drawings and etchings of night skies are conspicuously derived from photographs.) Yet while Crotty's handmade images evoke the immensity of the heavens, they also direct our attention to the artist's process of translating visual memories into images on paper, subjectively rendered with simple ballpoint pens.

As the title of his *Touchable Sky Over Oak Woodlands*, 2002, suggests, Crotty's images often imbue the nocturnal skies with an unfamiliar sense of intimacy. Like *Beyond the Waking World*, 2001, this work is mounted on a three-foot-diameter globe and suspended, inverting traditional notions of planet and heavens and allowing unparalleled viewing of a contained universe. Including images of desert plants backlit by the electric glow of Los Angeles, *Beyond the Waking World* also conveys the enormous and fluid shifts in scale and distance that characterize our experience of looking at the world. (This work's title comes from an H. P. Lovecraft prose poem about a city dweller who, peering out of his courtyard window, gradually senses the enormity of the universe.)

Milky Way Over Extreme Ponderosa, 2000, on the other hand, is a conventional flat drawing of the outer ranges of our galaxy as seen from atop Mount Pinos in California's Los Padres National Forest. This work represents Crotty's ongoing attempt to mix intellect and optical observation, science and aesthetics, in works that function like mini-planetariums, recreating the dome of the sky on an intimate scale. Toby Kamps

Russell Crotty was born in San Rafael, California, in 1956. He received a BFA from the San Francisco Art Institute in 1978 and an MFA from the University of California, Irvine, in 1980. Crotty has had solo exhibitions at the Kemper Museum of Contemporary Art, Kansas City, Missouri (2003) and the Contemporary Arts Museum, Houston (2003). His work also has been featured in many group exhibitions, including *For the Record: Drawing Contemporary Life*, Vancouver Art Gallery (2003); *Drawing Now: Eight Propositions*, Museum of Modern Art, New York (2002); and *Made in California 1900–2000*, Los Angeles County Museum of Art (2000).

Los Angeles

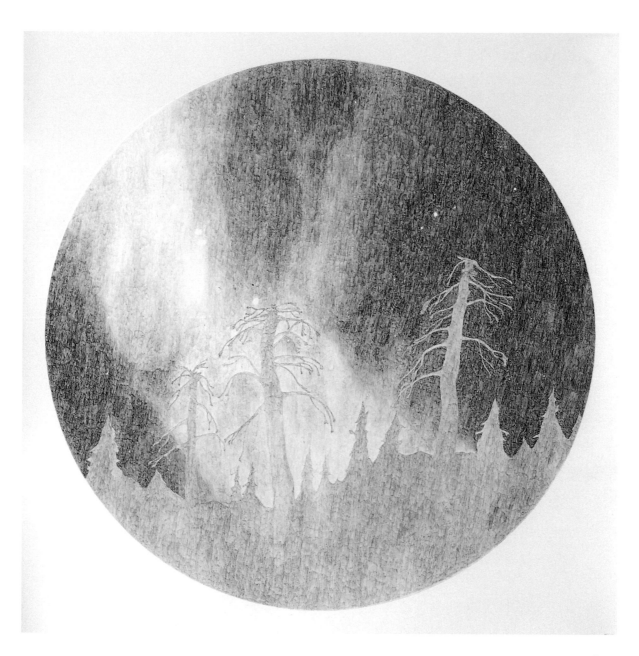

Above:
Russell Crotty
Milky Way Over Extreme Ponderosa, 2000

Overleaf left:
Russell Crotty
Touchable Sky Over Oak Woodlands, 2002

Overleaf right:
Russell Crotty
Beyond the Waking World, 2001

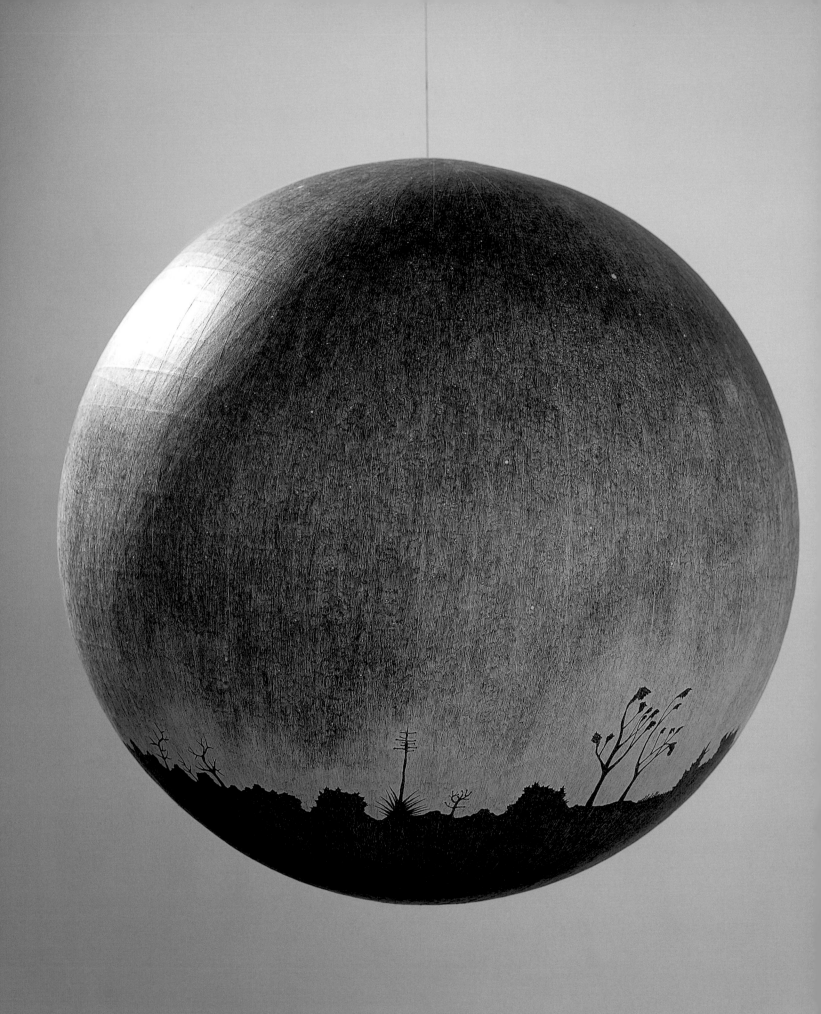

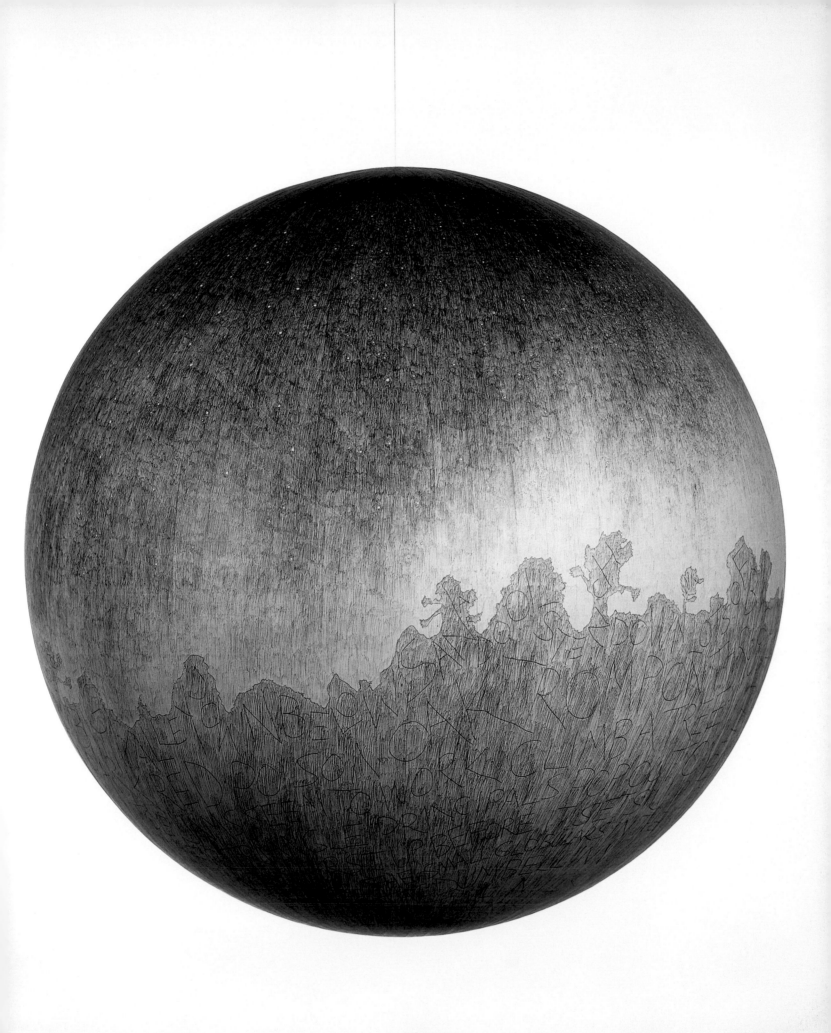

Roman de Salvo

Often making reference to aspects of the built environment, Roman de Salvo's sculptures—including faux fireplaces, hybrid lighting fixtures, and mazelike configurations of electrical conduits—evince a deceptively folksy appearance. Animated by verbal and visual puns, they are subversively funny works. Yet they are also consistently thoughtful, undermining our expectations about the nature of our performance as viewers of art while revealing a wry appreciation of the complexities of contemporary life.

Made from common materials, de Salvo's inventive sculptures often play off public situations, symbols, and monuments. For the 2000 Whitney Biennial, de Salvo created dozens of laptop-shaped plastic food trays with mirrors in place of computer screens. Titled *Face Time* and distributed in the museum's café, the work made dining a strangely self-conscious experience for its users, while conjuring the narcissistic isolation that characterizes so many aspects of our burgeoning technoculture. *Liquid Ballistic*, 2001, an outdoor work, takes the form of a wooden cannon that doubles as a seesaw, shooting out a jet of water when operated. Evoking ubiquitous military monuments as well as playground equipment and fountains (the three most common forms of outdoor sculpture), *Liquid Ballistic* invites viewers to participate in an amusing game where the balance of power tips without serious consequence. In works such as these, de Salvo not only focuses on the viewer's interaction with works of art but also underlines its public context. In addition, by reconfiguring public art in a humorous manner, his work defuses the self-importance that conventionally defines this genre. De Salvo's own ingenious aesthetic is decidedly antiheroic, calling to mind the work of an inspired garage tinkerer, rather than the product of an institutional commission.

All of these qualities are evident in de Salvo's *Yesterquest*, 2003, a sculptural installation commissioned for this exhibition. An interactive meditation on icons of West Coast history, the work consists of a wooden rocking chair with a rigid rope lasso extending up from its back and a ship's anchor trailing behind it on a stiffened chain. Sitting in the chair, the viewer is encouraged to find the proper rhythm to make the hinged loop swing like a halo over his or her head. Juxtaposing clichéd symbols of cowboys and conquistadors, *Yesterquest* is an absurd and satirical memorial that speaks to our passive consumption of archetypal myths of the West. As its title implies, the questing frontier spirit of exploration has been replaced in our era by a culture of nostalgia. Mocking the pervasive Disneyfication of the West's violent past, de Salvo's elegantly crafted sculpture—at once comfortingly familiar and comically disconcerting—gently jolts (or rocks) us out of habitual patterns of consuming history as well as works of art. TK

Roman de Salvo was born in San Francisco, California, in 1965. He received a BA from California College of Arts and Crafts in 1990 and an MFA from the University of California, San Diego, in 1995. De Salvo has completed sculptural commissions for the Musée d'Art Américain, Giverny, and the Museum of Contemporary Art San Diego. He has participated in numerous group exhibitions, including the California Biennial, Orange County Museum of Art, Newport Beach (2002); inSITE2000, San Diego/Tijuana; and the Whitney Biennial (2000).

San Diego

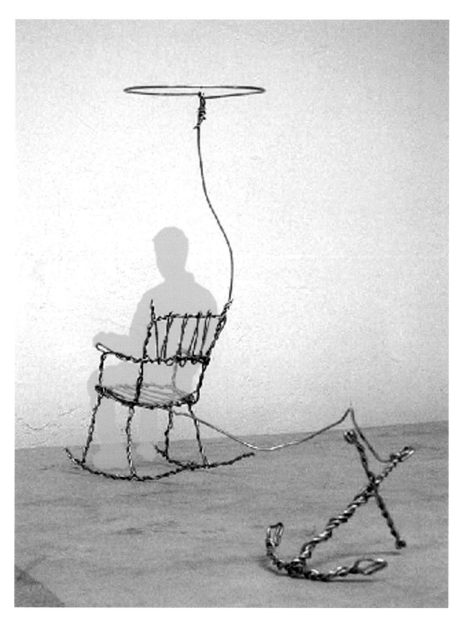

Roman de Salvo
Yesterquest, 2003

Trisha Donnelly

Art, like religion, requires of its adherents a certain leap of faith. However, a skeptical art-viewing public, imagining themselves the brunt of in-jokes delivered by a condescending elite, has for more than a century remained obstinately wary if not downright suspicious of the claims made on art's behalf.

Trisha Donnelly seems to enjoy and even revel in this conundrum. In the summer 2002 issue of *Artforum*, the artist and critic John Miller describes her working method thus: "Instead of asking viewers to suspend disbelief, [Donnelly] prods their credulity, pitting humdrum artifice against deadpan preposterousness." Donnelly's works operate as both conceits and deceits. Things may or may not be what they seem. Consequently, her works operate as conceptual sleights of hand. *Malibu*, 2002, is a case in point. It is ostensibly a straightforward black and white photograph of a nocturnal coastal scene. Were it not for its title, the image could well be just about anywhere. Given its title and its self-conscious ambiguity, *Malibu* fails as a literal description of the upscale oceanfront suburb of Los Angeles. Instead *Malibu* evokes an idea of how its namesake might exist in either the artist's or the public's imagination. Malibu becomes not so much a place as a state of mind—a conceptual leap that echoes Ed Ruscha's famous proposition that "Hollywood is a verb."

Similarly, *Blind Friends*, 2000—a C-print of a video still that shows a group of people at the beach—basks in its uncertainty. Whether these people are really blind, or even friends, is moot. Perhaps, as with the saying "love is blind," Donnelly is musing on the nature of friendship. But we could speculate endlessly—and maybe this is her point. The artist's own explanation of the image doesn't necessarily make things any clearer. According to Donnelly, *Blind Friends* is the only documentation of an action she organized in which a group of blind people were taken to the beach and asked to head off in what they thought was the direction of the wind. What followed—the almost random dispersal of the group, with each person heading off in a different direction—speaks volumes about the nature of subjective interpretation.

In an untitled video of 1998–9, the artist, dressed in white, leaps (with the aid of a trampoline) in and out of the frame. At the apex of each leap, momentarily frozen in midair, Donnelly affects a facial or physical gesture which, she claims, is derived from epiphanic or ecstatic moments in rock performances by artists such as Iggy Pop and David Lee Roth. Without access to recordings of the original performances, we have little choice but to accept the artist's word. Or, to put it another way, we are asked to believe.

Like Duchamp's before her, Donnelly's art is an occasion for serious play. Playing truths off falsehoods, she allows the rational and the irrational to coexist. Privileging doubt, her works seem ultimately to confirm that we should never take anything for granted. MH

Trisha Donnelly was born in 1974 in San Francisco, California. She received a BFA from the University of California, Los Angeles, in 1995 and an MFA from Yale University School of Art in 2000. In 2002 Donnelly had solo exhibitions at Casey Kaplan 10-6, New York, and Air de Paris, Paris. Donnelly's work has been included in group exhibitions such as the Venice Biennale (2003); *Moving Pictures*, Solomon R. Guggenheim Museum, New York (2002); and *A Little Bit of History Repeated*, Kunst-Werke, Berlin (2001).

San Francisco

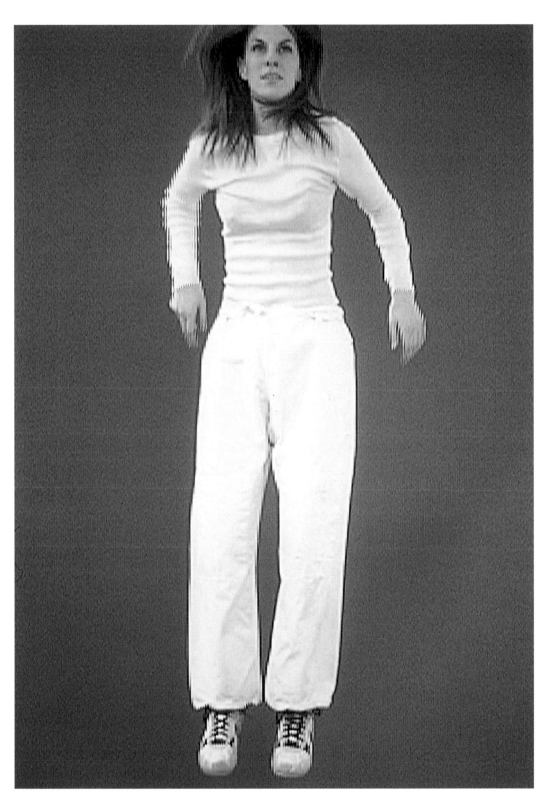

Trisha Donnelly
Untitled, 1998–9

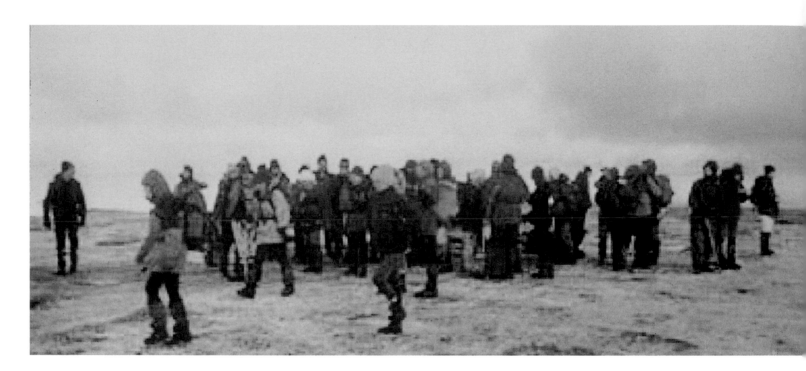

Trisha Donnelly
Blind Friends, 2000

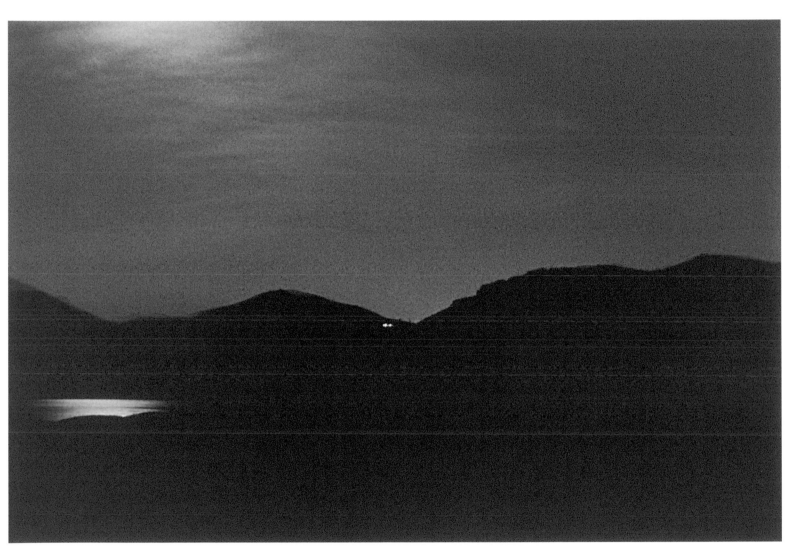

Trisha Donnelly
Malibu, 2002

Stan Douglas

Stan Douglas's project of the past two decades has been to grapple with the legacies of modernism, casting doubt on some of its utopian aspirations. Central to his work is an investigation of how social histories and political topographies are represented through the filmed or photographic image. Douglas is skeptical of claims of impartiality made for the documentary format—a format that he inverts by self-consciously dramatizing the vernacular, in turn creating a hybrid form pitched somewhere between truth and fiction.

One of Douglas's recurring subjects has been the cyclical decay and renewal of urban centres. A recent group of works—the video *Journey into Fear*, 2001, and its accompanying photographs of Vancouver's harbour and urban core—examines how metropolitan centres fit into the mechanics of a global economy. *Every Building on 100 West Hastings*, 2001, is one of these related photographs, but it also stands apart as a powerful testament to the intense urban transformation affecting one of Vancouver's most significant city blocks. Once the centre of a thriving commercial district, West Hastings Street is now at the heart of Vancouver's poorest, most crime-ridden neighbourhood, where defeated protests against the infiltration of condominium towers in favour of low-cost housing have left the community in a state of civic neglect.

Douglas's twelve-foot-long portrait of the run-down, boarded-up, for-sale buildings of this street self-consciously invokes Ed Ruscha's seminal 1966 artist's book, *Every Building on the Sunset Strip*. Both works are distinguished by an exaggerated Cinemascope horizontality. Using digital technology, Douglas's spectacular panoramic view has been painstakingly amalgamated from twenty-one separate shots of buildings that possess significant cultural histories. Photographed at night with the aid of cinematic lighting and with the street closed to all foot and vehicle traffic, the image is devoid of the bustling human activity, including drug-dealing and prostitution, that usually characterizes this area twenty-four hours a day. Indeed, Douglas's photograph is distinguished by an uncanny stillness, a theatrical emptiness, that renders the image suspicious, leading us to wonder if all is not as it should be. Memorializing the failed promise of urban renewal schemes, *Every Building on 100 West Hastings* prompts us to look closely at a neighbourhood poised to begin another chapter in its troubled history. DAINA AUGAITIS

Stan Douglas was born in 1960 in Vancouver, British Columbia. He received an intermedia diploma from the Emily Carr College of Art in 1982. He has had solo exhibitions at venues including the Serpentine Gallery, London (2002); the Museum of Contemporary Art Los Angeles (2001); Vancouver Art Gallery (1999); and Centre Georges Pompidou, Paris (1994.) Douglas has participated in major international group exhibitions including Documenta 11, 10, 9 (2002, 1997, 1992); the Sydney Biennale (2000, 1996, 1990); the Johannesburg Biennale (1997); and the Whitney Biennial (1995).

Vancouver

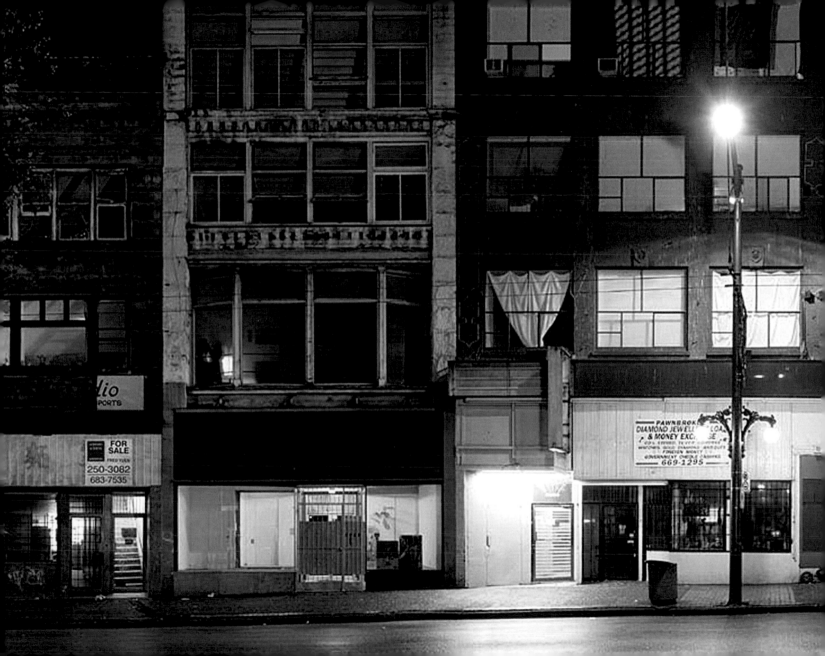

Stan Douglas
Every Building on 100 West Hastings, 2001
(detail, previous page)

Sam Durant

The Los Angeles–based artist Sam Durant has long been interested in the faded idealism associated with West Coast modernity. Masquerading as an activist, archaeologist, anthropologist, and cultural historian, Durant interrogates the recent past through his conflation of often conflicting social, political, and cultural ideologies.

In an early series of works Durant fabricated tabletop-scaled architectural models of modernist homes. Fashioned after the famous Los Angeles Case Study Houses of the 1940s and 1950s, in Durant's versions the homes appear abandoned, their plate-glass windows shattered and their white walls riddled with "bullet holes" as if the site of a drive-by shooting. In his *Proposal for Monument at Altamont Raceway, Tracey, California*, 1999, Durant evokes an iconic event of the late 1960s counterculture: the Rolling Stones' notorious 1969 free concert at Altamont, during which a concertgoer was killed by Hell's Angels the Stones had hired as security. Durant's proposed monument would sardonically "commemorate" a brutal and dystopian moment in recent West Coast history, one that signaled the beginning of the end for the peace-and-love hippie era.

In Durant's recent photographic series a racially harmonious group of models has been posed by the artist in tableaux that suggest late-1960s or early-1970s campus protests. In works such as *Landscape Art (Emory Douglas)*, 2002, and *Return*, 2002, Durant seems most interested in the commodification of dissent, in how radical ideologies capitulate to and are assimilated by parent cultures they once stood in opposition to—how dissent becomes little more than a lifestyle choice. Shot in the vacuum of a photographer's studio, the hired models—bearing placards with cryptic messages such as "Call/Response" or "Revolt/Return"—studiously and passively act out their roles. Posed as if for a Gap or Benetton shoot, Durant's "protesters" appear ideologically disenfranchised. (It's not clear—even in the bilious denouncement of landscape art in *Landscape Art (Emory Douglas)*—what exactly is being protested.) Emptied of any specific rhetoric and divorced from any identifiable political context, the models' placards—the signifiers of opposition and resistance—are rendered mute.

Through the creation of what might be termed "historical confusions," Durant reveals subliminal or otherwise repressed narratives that seek to unite the past with the present in an uneasy alliance. For Durant history ultimately remains an elastic and porous category, one that he is able to reimagine and reconfigure through a contemporary and often highly subjective lens untinted by nostalgia. MH

Born in Seattle, Washington, in 1961, Sam Durant received a BFA from Massachusetts College of Art in 1986 and an MFA from California Institute of the Arts in 1991. Recent solo exhibitions of his work have been presented at Wadsworth Atheneum Museum of Art, Hartford, Connecticut (2002); Museum of Contemporary Art Los Angeles (2002–3); and Kunstverein Düsseldorf, Germany (2001). Durant's work has also been included in the Venice Biennale (2003); *Rock My World: Recent Art and the Memory of Rock 'n' Roll*, CCA Wattis Institute for Contemporary Arts (2002); and *Out of Place: Contemporary Art and the Architectural Uncanny*, Museum of Contemporary Art, Chicago (2001).

Los Angeles

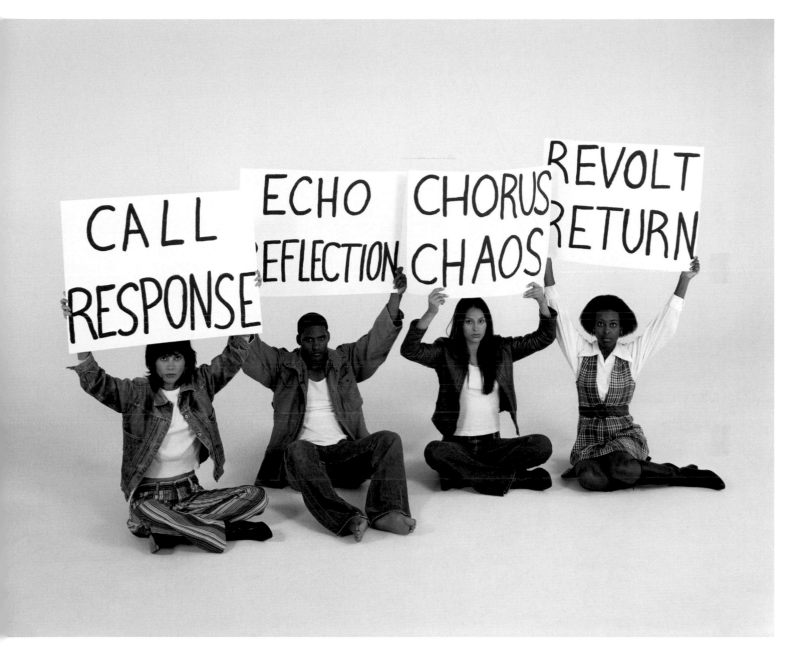

Sam Durant
Return, 2002

Thomas Eggerer

Thomas Eggerer's paintings exist in a state of suspension. Hovering somewhere between abstraction and figuration, they are based on generic images found in such common-place publications such as *National Geographic* and are painted in a seemingly provisional manner. Eggerer invariably depicts groups engaged in shared activities or experiences: playing sports, hiking, vacationing, or acting as spectators. With their self-conscious lack of detail or specifics, his paintings amplify the sense of unreality and unease that pervades social gatherings where individuals unwittingly cede their individuality to a mass identity or common cause.

Softball, 2001, depicts a sports crowd, wrapped in scarves, sitting on bleachers. Their attention is focused on the (unseen) action that is unfolding before them. They form a temporary community drawn together around a shared interest, and the lack of any animated social interaction amongst neighbors is pronounced. *Norma*, 2001, depicts a ferryboat, its deck populated by passengers who are preoccupied with their own thoughts or with the view. As in *Softball*, the ostensibly harmonious scene in *Norma*—which borders on a kind of romantic kitsch—seems to be a fragile façade held together by a collective investment in the possibility of community.

Eggerer's hesitant depiction of such scenes—with sketched-in and often unpainted areas—conveys a sense of incompletion, both of the images and the social tableaux they struggle to confirm. His strangely subdued paintings of our contemporary social landscape might be thought of as late-capitalist history paintings: apparently unassuming yet ultimately acerbic commentaries on our pervasive leisure society.

These concerns have preoccupied Eggerer since the mid-1990s when, still based in his native Germany, he worked with the artist Jochen Klein (1967–97) on projects that explored issues of consumerism, social identity, and sexual orientation. The two later joined forces with the New York–based activist art collective Group Material, collaborating on projects in the United States and Germany. Since that time and since his move to Southern California, Eggerer seems to have largely abandoned the activist platform of socially engaged art for a studio-based painting practice. At first glance, this decision might seem incompatible with his earlier intentions and motivations. However, the recurring themes of his paintings extend his investigation of the social landscape, exploring how nature has been commodified by the leisure industries; how spectatorship has become a largely passive activity; and how people operate, as individuals and as groups, in public space. MH

Thomas Eggerer was born in Munich, Germany, in 1963. He received a BFA from Munich Art Academy, Germany, in 1994 and an MFA from Vermont College in 1995. He has had recent solo exhibitions at Kunstverein Braunschweig, Germany (2003); Richard Telles Gallery, Los Angeles (2003); and Galerie Daniel Buchholz, Cologne, Germany (2002). Recent group shows include *Painting on the Move*, Kunsthalle Basel, Switzerland (2002); *Snapshot: New Art from Los Angeles*, UCLA Hammer Museum, Los Angeles (2001); and *Market*, Kunstverein Munich, Germany (1999).

Los Angeles

Thomas Eggerer
Norma, 2001

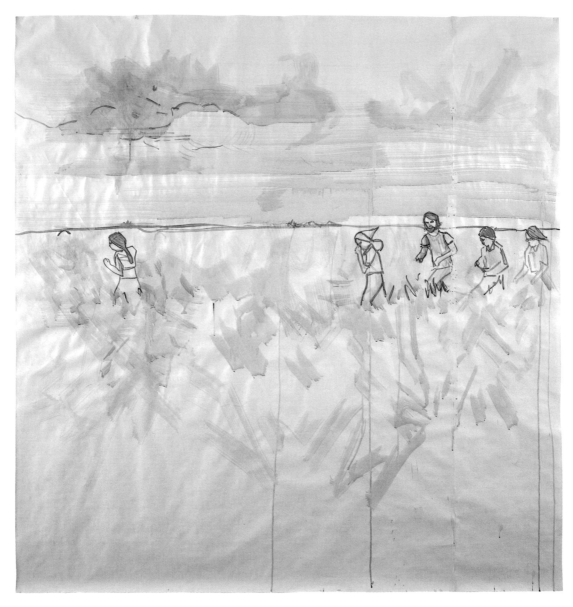

Thomas Eggerer
Onward, 2003

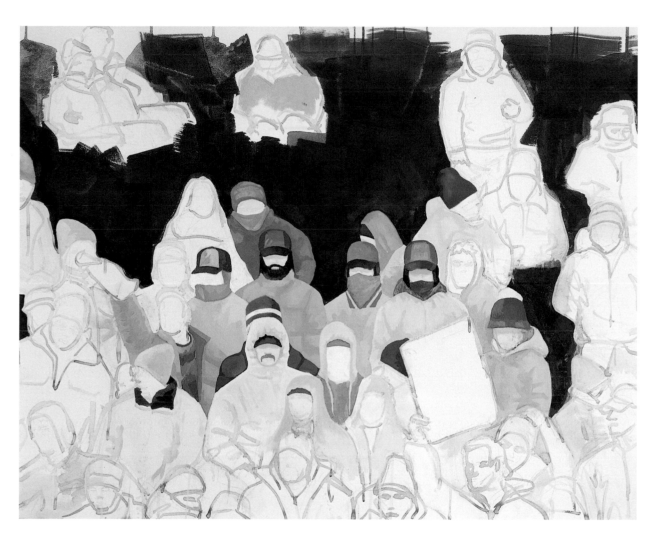

Thomas Eggerer
Softball, 2001

Kota Ezawa

The Simpson Verdict, 2002, is a short animated film by the San Francisco–based artist Kota Ezawa that reenacts the astonishing denouement of O. J. Simpson's 1995 trial: the moment at which Simpson was declared not guilty of the brutal murder of his ex-wife Nicole Brown Simpson.

The subject of thousands of hours of television news broadcasts, countless newspaper and magazine articles, and more than twenty books, the trial was played out in real time as a media spectacle. As events unfolded, it became clear that not only Simpson was on trial. America's obsessions with fame, privilege, wealth, and (most significantly) race all came under scrutiny. When Simpson was eventually cleared of the charges brought against him, the nation could not have been more shocked or divided. With his guilt and sentencing a foregone conclusion for certain sections of American society, justice was seen to have been both abused and betrayed.

The Simpson Verdict is abstracted from original courtroom footage of the trial. Animated in a simple, jerky style that echoes the offhand mannerisms of animated television series such as *South Park*, Ezawa's retelling of events focuses on and privileges the slight yet revealing gestures of Simpson and his legal team as they learn his fate. The turn of a head, the raising of an eyebrow, or the shifty movement of Simpson's eyes amplify the human drama of the trial's conclusion: the film reduces history to a series of idiosyncratic nervous gestures and tics. Through its use of animation—a two-dimensional approximation and graphic simplification of reality—*The Simpson Verdict* represents a key moment in recent American social history as if it were the subject of a Saturday morning children's television show.

Like *The Simpson Verdict*, *Home Video*, 2001, a short animated video of a generic suburban tract home, manifests Ezawa's fascination with surface and artifice. Endlessly passing from night to day, *Home Video* is—despite its *Simpsons*-like cheer—a surprisingly melancholic riff on the interminable monotony of contemporary suburban existence. Together Ezawa's works present us with an ultimately depressing picture of American society: a society increasingly alienated from itself (and the world at large), a society where mediated realities have all but eclipsed the possibility for and potential of authentic experience. MH

Born in Cologne, Germany, in 1969, Kota Ezawa received a BFA from the San Francisco Art Institute in 1994 and an MFA from Stanford University in 2003. Ezawa's work has been presented in numerous group exhibitions and film festivals including Bay Area Now 3, Yerba Buena Center for the Arts, San Francisco (2002); iMAGES Festival of Independent Film and Video, Toronto (2001); and the International Short Film Festival, Berlin (2000).

San Francisco

Kota Ezawa
Home Video (stills), 2001

Above and right:
Kota Ezawa
The Simpson Verdict (stills), 2002

Harrell Fletcher & Miranda July

Collaboration is central to the artistic practices of both Harrell Fletcher and Miranda July. July, known for her performances, movies, and literary works, often invites audiences to participate in live interactive works, casting audience members in roles central to the event. Fletcher creates opportunities for dialogue with other artists or members of communities in which he is invited to work. These dialogues provide him with the form and content of his installations and book projects, as well as the exhibitions he organizes as part of his practice.

Initially developed for the Institute of Contemporary Art (ICA) at Maine College of Art in Portland for the group exhibition *Playground*, 2002, their collaborative website, www.learningtoloveyoumore.com, enabled Fletcher and July to extend their respective collaborative practices beyond the dynamics of a single situation. Developed with designer Yuri Ono, the website invited volunteers on the Internet to complete one of five assignments and mail them to the ICA for the duration of *Playground*. The ICA displayed completed projects on shelves in the gallery space designated for each assignment. Visitors were also encouraged to use VCRs in the gallery to view videotapes. The website has continued to evolve with new assignments added by the artists regularly and since its premiere has been customized for communities in Houston and Hartford, abroad in Croatia, Vietnam, England, and Japan, and now for *Baja to Vancouver*.

Assuming the role of curators for this presentation, Fletcher and July have organized four distinct exhibitions, one for each venue, featuring both new and previously completed assignments from the learningtoloveyoumore.com website archives. The theme, choice of works, and scale of each exhibition is site-specific; that is, shaped by the artists' perceptions of the places where each venue is located and the possible interests of their respective audiences. Fletcher and July have used the opportunity offered by *Baja to Vancouver* as a traveling exhibition to connect the creative responses to assignments from all over the world directly to the lives of people living on the West Coast. LC

Born in Santa Maria, California, in 1967, Harrell Fletcher received a BFA from the San Francisco Art Institute in 1989), an MFA from California College of Arts and Crafts in 1993, and a Certification in Ecological and Sustainable Food Systems from the University of California, Santa Cruz, in 1995. His recent solo exhibitions include *Now It's A Party*, Real Art Ways, Hartford, Connecticut (2003); *Everyday Sunshine* (collaboration with Miranda July), Portland Institute for Contemporary Art, Portland, Oregon (2001); and *The Boy Mechanic*, Yerba Buena Center for the Arts, San Francisco (1999). His work has also been presented in group exhibitions including *Street Selections* at the Drawing Center, New York (2003); *Playground* at Institute of Contemporary Art, Maine College of Art, Portland (2002); and *Fast Forward* at the Berkeley Art Museum (2001).

Miranda July was born in Barre, Vermont, in 1974. Her performances and films have been included in group shows including the Whitney Biennial (2002); *Digital Showcase*, Institute of Contemporary Arts, London (2001); and *Drama Queens: Women Behind the Camera*, Solomon R. Guggenheim Museum, New York (2001). Her work has also been shown in film festivals including the International Film Festival, Rotterdam (1999); Underground Film Festival, Vancouver (2001); and the New York Video Festival (2002).

Portland

Harrell Fletcher & Miranda July
Learning to Love You More, 2002–ongoing
Assignment No. 2: Make a Neighborhood Field Recording
Morgan Rozacky, *Lester,* 2002

Evan Holloway

Possessed of a seemingly casual or slipshod aesthetic, Evan Holloway's eclectic production embraces and combines myriad forms, including sculpture, drawing, video, and installation. Often precariously or provisionally constructed, his works play the formal rigors of high modernism against hippie-era improvisation.

Part of a younger generation of Los Angeles–based artists that seeks to question the autonomy of modernist sculpture, Holloway approaches art-making as a vehicle for socially rooted and engaged dialogue. His *Incense Sculpture*, 2001, and *Left-Handed Guitarist*, 1998, are two distinct works that approximate vernacular forms of public sculpture: anonymous corporate abstraction, on one hand, and civic commemorative statuary, on the other. If most public art seeks to confirm, validate, or vindicate the vested interests of the civic or corporate bodies it represents, Holloway's "public sculptures" instead challenge these peculiar concerns or assumptions through the almost comical juxtaposition of formalist sculptural tropes and motifs that conjure unashamedly narcissistic introspection or new-age mysticism.

A Möbius loop fashioned from an undulating, square section of plaster, *Incense Sculpture* superficially echoes the kind of generic late-modernist abstract sculpture "inspired" by the works of Brancusi, Moore, or Noguchi that can be found gathering dust in corporate atriums or littering traffic medians throughout Los Angeles. But the work's zenlike formal harmony is rudely interrupted by two incongruous elements that undermine its *über*-rational gestalt: the handmade, almost folksy texture of the plaster and the burning incense stick that protrudes from its surface. Through its redesignation as a functional object—albeit little more than an overblown incense holder—*Incense Sculpture* operates as a sardonic send-up of both modern sculpture and West Coast mysticism.

Left-Handed Guitarist offers another take on art's transformative aspirations. A dysfunctional riff on the ubiquitous civic statuary to be found in public parks and town squares, *Left-Handed Guitarist* is ostensibly a portrait of the self-destructive Seattle rock star Kurt Cobain, whose 1994 suicide ensured his place in rock's hall of infamy. Carved out of Styrofoam, the figure of the guitarist balances uneasily on a precipice, apparently engaged in a quest for inspiration or personal enlightenment while staring into a schematic drawing of a vortexlike abyss. Mixing references to high and low culture in the artist's signature fashion, the work, with its head-hanging sullenness and stoner obsessiveness, seems to suggest that everyone, no matter how socially or emotionally disaffected, has a shot at transcendence. TK

Born in La Mirada, California, in 1967, Evan Holloway received a BA from the University of California, Santa Cruz, in 1989 and an MFA from the University of California, Los Angeles, in 1997. He has had solo exhibitions at Xavier Hufkens, Brussels (2002); The Approach, London (2001); and Marc Foxx, Los Angeles (1999). His work has been featured in numerous group exhibitions, including the Whitney Biennial (2002); *the americans. new art*, Barbican Art Gallery, London (2001); and *Mise-en-Scène*, Santa Monica Museum of Art (2000).

Los Angeles

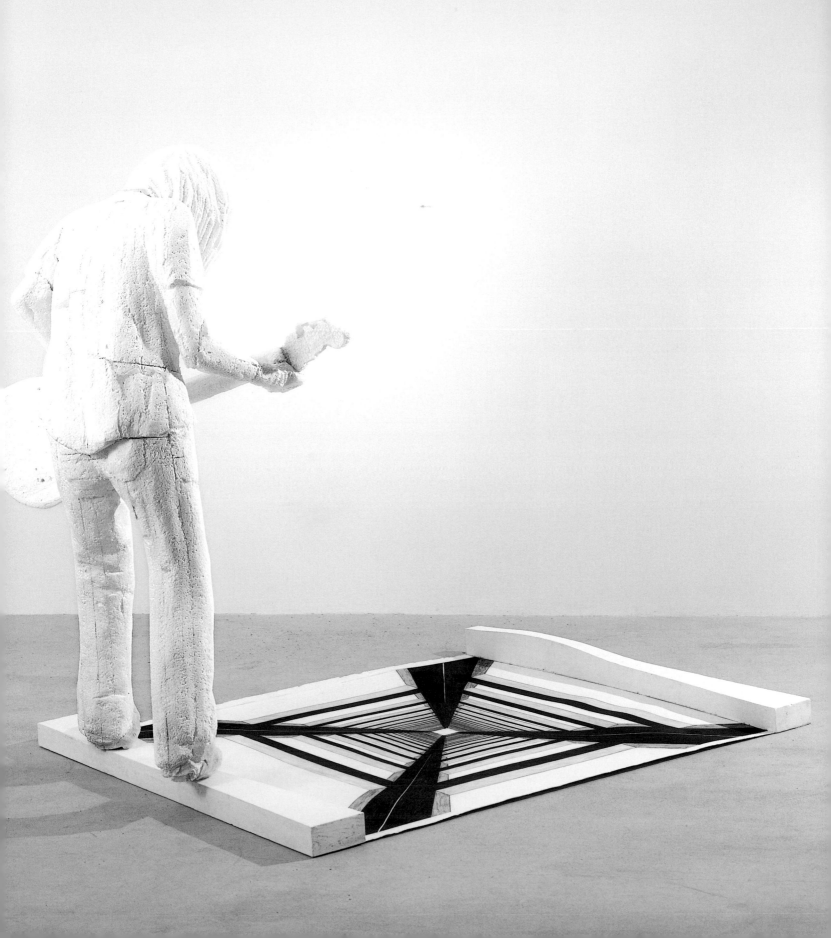

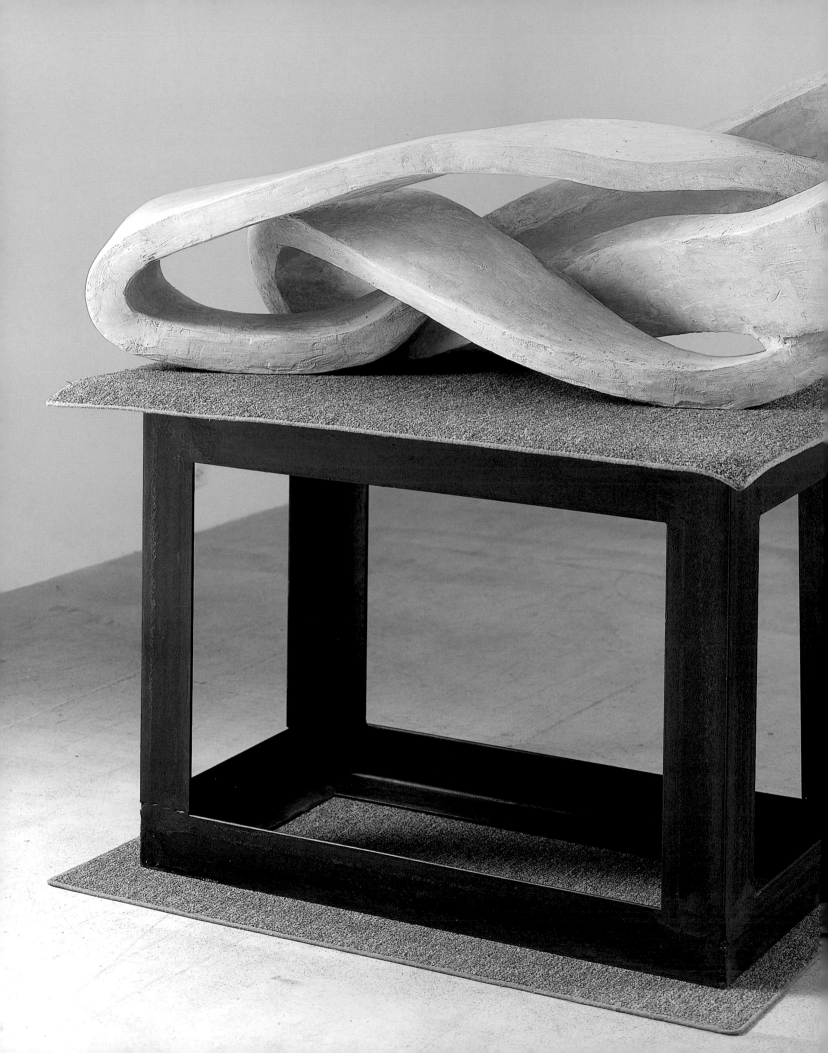

Previous page:
Evan Holloway
Left-Handed Guitarist, 1998

Left:
Incense Sculpture, 2001

Chris Johanson

Chris Johanson approaches the world as both a documentarian and a diarist, carefully recording and absorbing the metropolitan hubris that surrounds him. Johanson is associated with a discrete group of artists—including Barry McGee, Jo Jackson, and Rigo 03—linked with San Francisco's Mission District, home to the city's Mexican community and its eclectic art scene. Common to these artists is their approximation of the vernacular visual motifs and languages that proliferate on almost every street corner of their neighborhood in graffiti, murals (both official and improvised), and other urban folk art forms.

Like the street art from which it draws its inspiration and its rationale, Johanson's work is at once private and public. Johanson borrows from street art a desire to communicate his intentions more urgently. Eschewing ambiguity, his disarmingly simple drawings, paintings, and sculptural installations crystallize, in the words of critic Carlo McCormick in *You Are There*, "San Francisco's particular mix of alienated workers, drug casualties, down and out street-level denizens of the wrong end of the American dream and motley vestiges of that town's remarkable half-century history of bohemian subculture" (Alleged Press, 2000).

Johanson's installation *This Temple Called Earth*, 2003, is a self-contained cosmos within a structure resembling an igloo, which the viewer enters through a precariously low opening. Inside, the domelike interior is painted a calm celestial blue, reminiscent of a scaled-down planetarium. At center stage is a folksy, painted wooden tableau of a redwood forest, displayed on a pedestal and surrounded by a low Plexiglas barrier, as if in a natural history museum. In a series of paintings uncomfortably lodged in a neighboring alcove, city dwellers are stacked atop one another, trapped in the daily grind of urban alienation. *This Temple Called Earth* is a melancholic riff on the divide between the humdrum realities of contemporary urban life and the utopian promise of the rural West Coast. Nature is reduced to an unattainable abstraction, a folk art simulacrum of itself.

Like Constantin Guys, Charles Baudelaire's fictional nineteenth-century "painter of modern life," Johanson arrests the constant flux of daily life with the canny insight of a flaneur. And for McCormick, Johanson displays a "nonjudgmental fascination for how private lives are maintained in public view." Johanson clearly empathizes with the shifting cast of characters populating his works, who are prone to expressing their thoughts publicly through speech bubbles, as if on the pages of a comic book. Seemingly overwhelmed by the trials of modern life, his characters often ask unanswerable or rhetorical questions of themselves, or of anyone who cares to listen. From the babble of often conflicting and contradictory voices emerges a clear picture of a community at loggerheads with itself, struggling to make sense of it all. MH

Chris Johanson was born in San Jose, California, in 1968. His work has been shown in solo exhibitions at the Jack Hanley Gallery, San Francisco (2003); Deitch Projects, New York (2002); and the UCLA Hammer Museum, Los Angeles (2001). Johanson's work has also been presented in group exhibitions including Art Basel: *Statements* (2003); the SECA award exhibition, San Francisco Museum of Modern Art (2003); and the Whitney Biennial (2002).

Oakland

Chris Johanson
This Temple Called Earth, 2003

Brian Jungen

Brian Jungen is part of a younger generation of conceptually based Vancouver artists who are interested in popular culture and whose work engages with representations and simulacra, alluding to the influential presence of the city's growing movie industry. In witty conceptual inversions, Jungen transforms everyday objects into cultural hybrids that comment on their original sources. Including works that reconfigure Nike trainers into startling evocations of Northwest Coast First Nations masks or that craft cut-up plastic patio chairs into enormous suspended whalelike skeletons, Jungen's art redeploys the basic material elements of commodities, while prompting us to rethink how such objects operate in a global economy and how they can be transformed instead into something that stirs local cultural memory.

The dialogue around Jungen's sculptures is not just about consumerism but also about institutional cultures, be they those that thrive in anthropology museums, art galleries, or prisons. He is especially interested in subverting the conventions of museum display, presenting objects that counteract the dominant narratives typically upheld in such places. For example, the works made of Nike trainers in the series *Prototypes for New Understanding* are displayed in authoritative museum vitrines, a form of presentation that conveys the power of an institution's legitimizing role. It also reminds us of the role of Northwest Coast masks as souvenirs of cultural exploitation, rather than as sacred objects used in age-old rituals for communicating with the spirit world. Jungen's ironic displacements force his objects and museum contexts into new relationships, ones that aim to redress contested colonial histories.

In this series of over one dozen works, Jungen uses different elements of the Nike shoe to depict, but never replicate, distinct features of Northwest Coast masks. Of particular importance is their colour—red, white, and black—a classic combination derived from this particular style of Nike Air Jordans and one that is prevalent in many Northwest Coast aboriginal motifs. There is also the Nike "swoosh," a stylized V for victory, which in Jungen's strategic placement becomes a reference to the classic ovoid shape that is basic to Northwest Coast two-dimensional representation and questions the meaning of victory. In Jungen's *Prototypes*, as well as in his wall reliefs, such as *Variant #1*, 2002, he literally rips into the icons of trendy consumer culture to question contemporary society's stereotypical representations of aboriginal cultures. DA

Brian Jungen was born in 1970 in Fort St. John, British Columbia. He received a diploma in fine arts from Emily Carr College of Art and Design in 1992. He has had solo exhibitions at Secession, Vienna (2003); Contemporary Art Gallery, Vancouver (2001); and Charles H. Scott Gallery, Vancouver (1999). Recent group exhibitions include *I Moderni/The Moderns*, Castello di Rivoli, Turin (2003); *Hammertown: Eight Artists from Canada's West Coast*, Fruitmarket Gallery, Edinburgh (2002); and *ARS 01*, Kiasma Museum of Contemporary Art, Helsinki (2001).

Vancouver

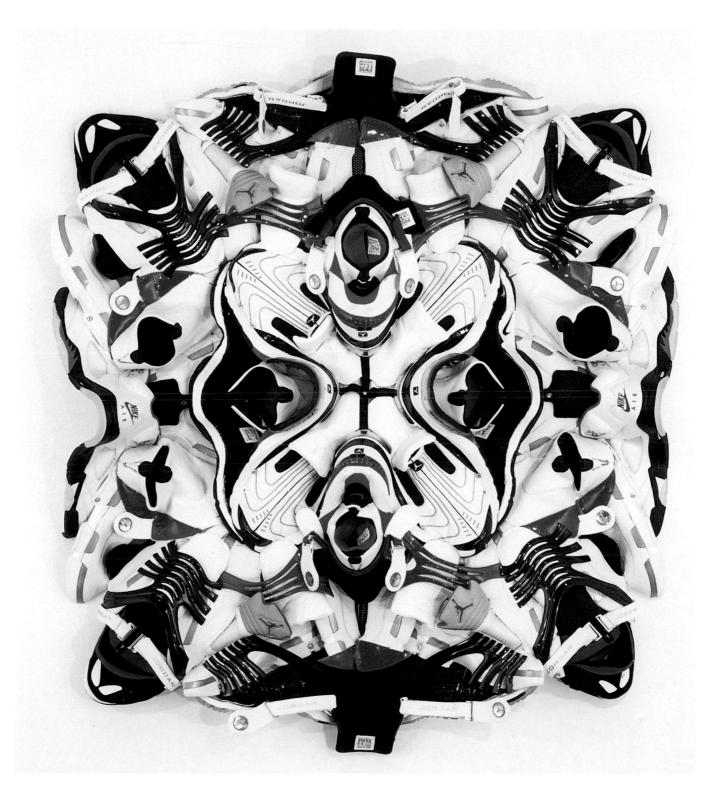

Brian Jungen
Variant #1, 2002

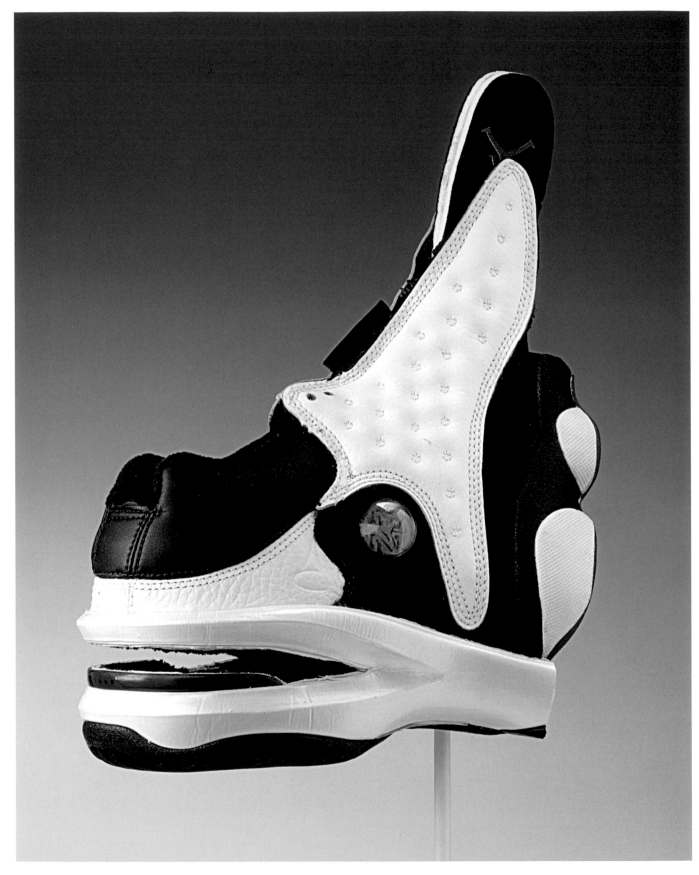

Brian Jungen
Prototype for New Understanding #3, 1999

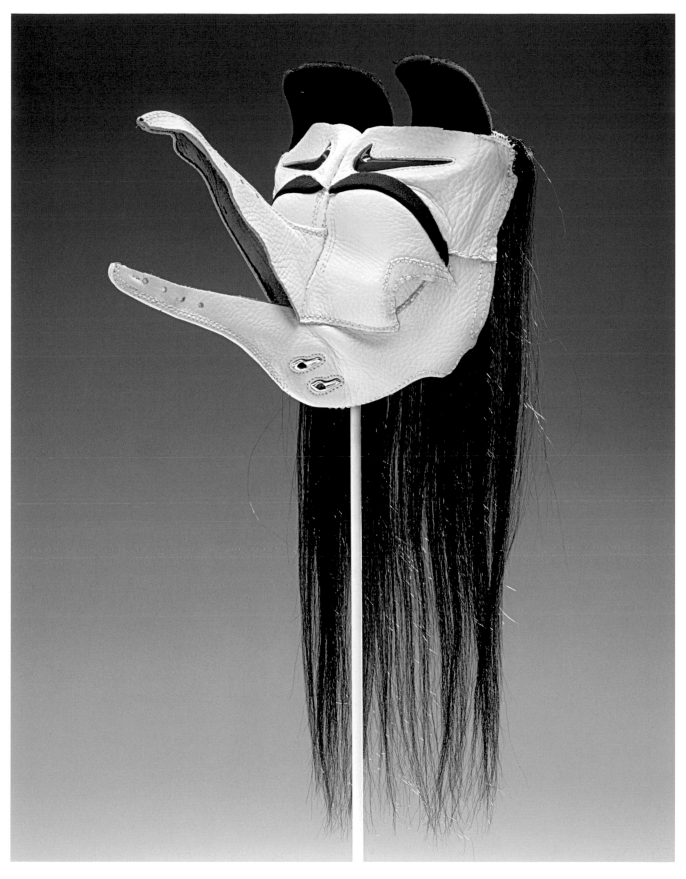

Brian Jungen
Prototype for New Understanding #2, 1998

Tim Lee

At the heart of Vancouver-based artist Tim Lee's practice lies the complex issue of translation: how an event, image, or musical score is transformed (and corrupted) through the process of being restaged or reinterpreted. Lee's work is also underpinned by a questioning of ethnicity and cultural identity, in particular the artist's own hybrid identity as an Asian Canadian. Lee himself is, invariably, the central subject of his works, which take the form of quasi-documentary accounts of staged performances and role-playing actions that typically reference iconic moments in North American popular culture.

Lee followed this strategy in a 2001 four-channel video work for which he taught himself the vocal, guitar, bass, and drum parts of the mid-1950s Richard Berry standard, "Louie, Louie." (Like a one-man garage band, Lee appears on different monitors playing each part.) Making reference to the song's numerous incarnations and The Kingsmen's popular 1963 cover version, Lee calls attention to the song's status as a translation of a translation of an original, a process that acutely brings into focus questions of authorship, authenticity, and identity.

Similarly, in the three-channel video installation *The Move, The Beastie Boys, 1998*, 2001, Lee reenacts the intricate tag-team rhyming of Beastie Boys Adam Yauch, Mike Diamond, and Adam Horovitz's performance of their 1998 song "The Move," creating a video triptych in which he "raps" all three parts. Echoing the formal restraints of much early video art—fixed camera positions, shot in black and white—Lee fills each monitor with a closely cropped image of his face as he deadpans the original lyrics without musical accompaniment. Lee, of course, is aware of the irony of an Asian-Canadian artist aping white American Jewish rappers, who themselves are mimicking African-American hip-hop styles; but, as he sees it, this process of cultural fracturing and assimilation simply adds yet another layer to the song's already convoluted Buddhist-flavored humanist rhetoric.

The just barely competent nature of his "performances" is a crucial part of Lee's work. Like a Walter Mitty of the information age or a stand-in for obsessed fans, Lee reenacts rituals of pop culture that are usually the domain of acknowledged practitioners or experts. He accepts that there is a degree of "stupid heroism" in what he does—because he is neither a performer nor a musician—and that it is only through his own conviction in his endeavors that he is able to transform the ridiculous into something that simultaneously suggests the sublime. TK

Tim Lee was born in Seoul, South Korea, in 1975. He received a BDes from the University of Alberta in 1999 and an MFA from the University of British Columbia, Vancouver, in 2002. He has had solo exhibitions at Or Gallery (2002) and the Western Front (2001) in Vancouver. His works have also been included in group exhibitions such as the Prague Biennial (2003); *Soundtracks*, The Power Plant, Toronto (2003); and *Vancouver Video*, Folly Gallery, Lancaster, England (2002).

Vancouver

IT'S TIMES LIKE THIS WHEN I JUST CAN'T STOP CAN'T WIND YOUR BODY WITHOUT THE BODY ROCK GOT SCHEMES SCHEMATICS BLUEPRINTS ON FILE YOU GOTTA HAVE DREAMS TO MAKE IT ALL WORTHWHILE SO AS I TAKE MY TIME AND REALIGN I WONDER WHAT IT IS I HOPE TO FIND I DON'T MEAN TO BRAG I DON'T MEAN TO BOAST BUT I'M INTERCONTINENTAL WHEN I EAT FRENCH TOAST ADROCK WITH THE NEW EDITION GETTIN' ON DOWN FOR THE YEAR TWO THOUSAND A SLIGHT DISTRACTION CAN GET YOU PAID AND WHEN IT COMES TO THAT TYPE SHIT I PAVED THE WAY B-BOYS TO THE EARLY MORN B-GIRLS BE ROCKIN' ON AND ON B-GIRLS TO THE BREAK OF DAWN B-BOYS BE ROCKIN' ON AND ON

DOGS LOVE ME CAUSE I'M CRAZY SNIFFABLE I BET YOU NEVER KNEW I GOT THE ILL PERIPHERAL IN YOUR HOME I'M CLONED I'M ON YOUR HEADPHONES I LOVE IT WHEN YOU SPAZZ OUT ALL ALONE CAUSE I'M THAT FOOL THAT BROKE THE KEY I'M UNLOCKABLE SO DON'T CHECK ME I GOT WEIGHT ON MY SHOULDERS AND THINGS ON MY MIND THE SKY IS FALLING AND I'M FALLING BEHIND SO I SYNTHESIZE SOUNDS AS I PATCH MY BRAIN INSANE MIND GAMES MOVE QUICK LIKE FLAMES SO NOW I WONDER HOW SOMETIMES YOU NEVER KNOW WHO BE ROCKIN' Y'ALL IN STER-E-ER-E-O IN STER-E-ER-E-O IN STER-E-ER-E-O IN STEREO

NO TIME LIKE THE PRESENT TO WORK SHIT OUT THAT'S WHAT I'M GOING ON AND ON AND ON ABOUT I'M NOT FAKIN' JUST MAKIN' BEATS IN THE DUNGEON TO KEEP THAT SHIT FUNKY CAUSE THE ODOR IS PUNGENT NO SHAME IN MY GAME JUST PAR FOR THE PATH I TRY TO HONE MY CRAFT BECAUSE AT HANDS THE TASK BUT I FIND I'M NOT PLAYING WITH A FULL DECK I'M UP TO MY NECK LIKE TOULOUSE LAUTREC ALL I WANNA KNOW IS WHEN IS CHECKOUT TIME SO I COULD BE IN HEAVEN WITH THE RHYTHM ROCK RHYME AND WHEN I'M WITH MY MAN SHADI ROCK AT THE GATES WE'LL BE ROCKIN' RHYTHMS OVER DISCO BREAKS B-BOYS TO THE EARLY MORN B-GIRLS BE ROCKIN' ON AND ON B-GIRLS TO THE BREAK OF DAWN B-BOYS BE ROCKIN' ON AND ON

Tim Lee
The Move, The Beastie Boys, 1998, 2003
4-color silk screen
(catalog only)
Lyrics © The Beastie Boys

Tim Lee
The Move, The Beastie Boys, 1998, 2001
(detail, right)

Ken Lum

Since the 1970s, Ken Lum has judiciously incorporated vernacular images, texts, signs, and objects from urban culture into his work to explore the interplay of identities in our increasingly globalized economy. Using a broad range of media, including video, installation, performance, sculpture, painting, and photography, he has claimed an eclectic array of public sites for his art—such as shopping malls, billboards, freeways, rooftops, and the Internet.

Throughout his career Lum has made works in the form of portraits, typically combining a photographic image with a strong graphic component composed of fictitious names, corporate logos, emblematic slogans, or emotional quotes that offer telling provocations to the image. The men and women portrayed in these works represent the broad range of ethnicities found in a New World city such as Vancouver, where waves of immigration from all continents have resulted in a multicultural society. As Lum's art makes clear, "home" takes on complex meanings in such an environment, where inhabitants are constantly transformed by their surroundings and conflicts are never far from the surface.

Lum explores a different form of portraiture in a recent series, for which he has adapted a type of low-end commercial signage. In these marquee-like signs, Lum has juxtaposed the logos of small businesses with personal messages from their owners. Although devoid of images, these works still function as portraits, illuminating the dilemmas, vulnerabilities, and tensions of city dwellers caught in a matrix of personal and cultural trauma.

In *Amir New and Used*, 2000, a sign advertising a closing-out sale includes the text "moving back to Eritrea," leaving us to wonder if the New World has failed to live up to its promise for Amir. Is this shopkeeper relocating to one of the world's more dangerous countries out of choice, or because he has been unable to find a place in his adopted city? And in *Grace Chung Financial*, 2001, where the sign reads, "Please leave/my family alone/whoever you are/deal with me," the covert harassment of an Asian family is brought sharply into the public eye. Despite the text's lack of specific detail, one cannot help but read between the lines and imagine racial intimidation as the catalyst for Grace Chung's plea.

In terse works such as these, Lum disrupts the smooth veneer of advertising and asks us to consider how personal and local narratives are affected by—and implicated in—a larger global politics. Between the logos on the upper part of Lum's signs and the impassioned messages below, the viewer engages the space of the in-between—between public and private, fact and fiction, local and global—encountering contradictions that can destabilize existing stereotypes and generate new meanings. DA

Ken Lum was born in 1956 in Vancouver, British Columbia. He studied at Simon Fraser University and received an MFA from the University of British Columbia in 1985. He has exhibited extensively, with recent solo shows at the Canadian Museum of Contemporary Photography, Ottawa (2002); FRAC de Haute-Normandie, Yvetot, France (1997); and Camden Arts Centre, London (1995). Group exhibitions include Documenta 11, Kassel (2002); the Venice Biennale (2001, 1995); the Shanghai Biennale (2000); the Johannesburg Biennale (1997); and the Carnegie International (1991).

Vancouver

GRACE CHUNG
FINANCIAL
CONSULTANT

EXPERTISE YOU CAN TRUST

CALL FOR APPOINTMENT & NEWSLETTER

(778) 238-2888

PLEASE LEAVE
MY FAMILY ALONE
WHOEVER YOU ARE
DEAL WITH ME

Ken Lum
Grace Chung Financial, 2001

Liz Magor

In Liz Magor's work, nothing is as it seems. Highly realistic and precisely detailed, Magor's sculptural still lifes beguile viewers with their credible simulations of natural and man-made objects. But Magor's proplike artworks typically conceal more than the artifice with which they are made; motifs of hiding and hoarding also run through her work, as many of her sculptures resemble secretive containers or shelters.

Cast from a real British Columbia cedar, *Hollow*, 1998–9, looks like an actual fallen log, convincingly detailed down to the textured minutiae of its shady bark. But beyond the persuasive illusion of its exterior, another, contradictory story speaks through the materials of its making. The log is in fact only a thin polymerized shell whose interior is lined with carpet underlay, transforming it into a makeshift shelter equipped with a grubby sleeping bag. What first appeared as nature is revealed to be a cultural artifact, a rudimentary dwelling that calls to mind the temporary haven of a hiker or the claustrophobic refuge of a homeless person or social misfit.

The perceptual confusion engineered by Magor's trompe l'oeil sculptures often finds an echo in their uncanny conflation of nature and culture. Another work, *KD–the Original*, 2000, also plays on the disjuncture between urban and rural, original and facsimile, as bits of macaroni and grated cheese leak onto the floor from an expertly crafted silicone replica of a worn leather backpack. (The title refers to the Kraft Dinner box presumably stored inside the pack.) Ironically hinting at the way we search for "authentic" nature laden with the "original," taste-defining commodities of our consumer society, Magor's sculpture refuses to map out a full narrative. Instead, as with most of her work, it leaves viewers to observe carefully, discover what is hidden, and spin their own stories.

In Magor's *Double Cabinet (blue)*, 2001, a supply of Kokanee beer is concealed behind the false exterior of what initially appears to be a stack of folded towels. Hinting at furtiveness and paranoia, this sculpture also examines our relationship to the ersatz and the fake. With their recognizable imagery of the Canadian Rockies, the Kokanee labels seemingly invoke our vicarious consumption of nature, which as an advertising trope typically functions as a symbol of purity. Yet there is nothing pure about the value of images, Magor reminds us, as she consistently undermines our initial impressions. Instead, their meaning is rooted in duplicity, contingent acts of interpretation, and the unreliable play of appearances. DA

Liz Magor was born in Winnipeg, Manitoba, in 1948 and studied at the University of British Columbia, Parsons School of Design, and Vancouver School of Art, from which she received a diploma in 1971. She has had solo exhibitions at The Power Plant, Toronto (2003); Vancouver Art Gallery (2002); and Art Gallery of Ontario (1986), among others. Her work has also been shown in group exhibitions including insITE1997, San Diego/Tijuana; *More than One Photography*, Museum of Modern Art, New York (1992); and Documenta 8, Kassel (1987).

Vancouver

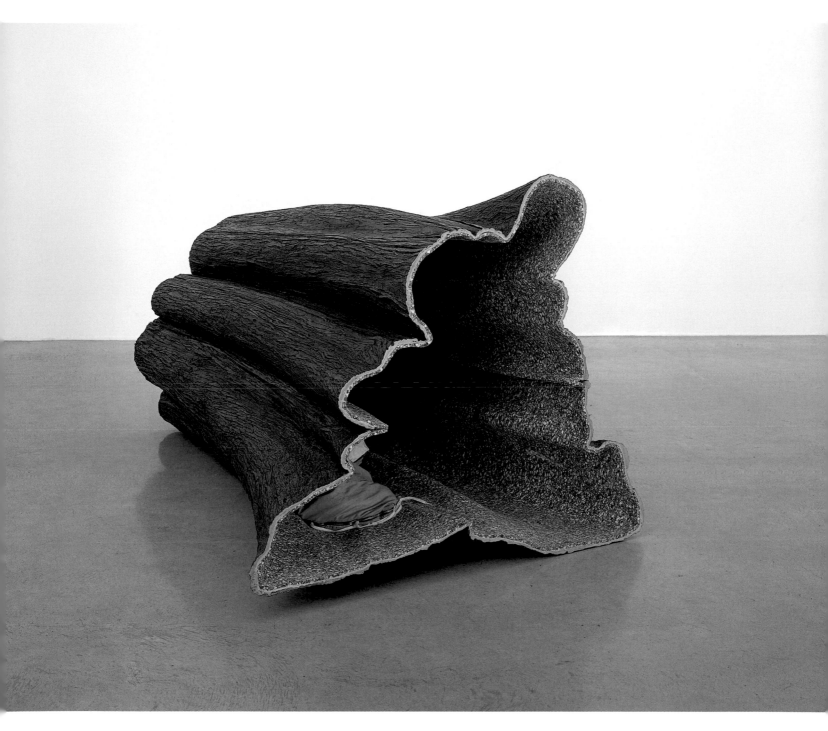

Liz Magor
Hollow, 1998–9

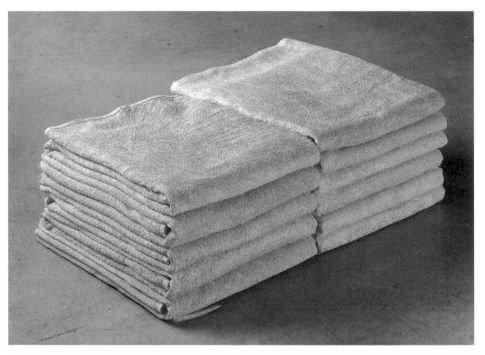

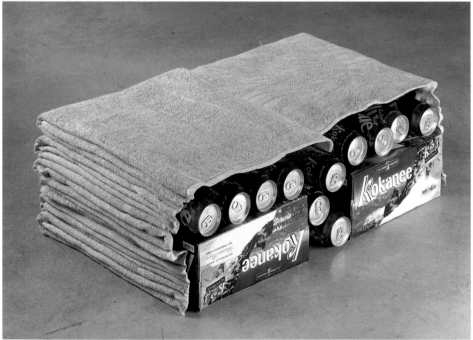

Above:
Liz Magor
Double Cabinet (blue), 2001

Right:
KD–the Original, 2000

78

Matt McCormick

In recent years, Portland has become a significant center for experimental film and video, energized by the presence of directors Gus Van Sant and Todd Haynes, the PDX (Portland Documentary and Experimental Film Festival), and Peripheral Produce, which brings anthology shows of Northwest filmmakers to other cities and presents local and international works. Founded in 1996 by Matt McCormick, both Peripheral Produce and Rodeo Films, its distribution arm, are typical examples of the do-it-yourself approach evolved by Portland's underground artist community to bring its work to the public.

McCormick's filmic explorations of his adopted city include *Going to the Ocean*, 2001, a poetic and abstract homage to the sights and sounds of the industrial waterfront where he lives, and *The Subconscious Art of Graffiti Removal*, 2002. Parodying the documentary genre, the latter work focuses on the "unconscious and collaborative" art that inadvertently comes into being through the efforts of city employees to paint over graffiti. McCormick's filmed images of the rectangular forms left on walls, train cars, and shipping containers are accompanied by a deadpan voiceover, provided by fellow artist Miranda July. Adopting the authoritative tone of an academic art historian in analyzing the artistic "compositions" created by graffiti removal teams, July compares their work to that of well-known abstract painters such as Kasimir Malevich and Mark Rothko ("the forefather of the graffiti removal movement"). July even uses tidy stylistic categories and genres in reviewing the different compositional approaches of these inadvertent artists.

The droll, deadpan tone of *The Subconscious Art of Graffiti Removal* recalls a number of Ed Ruscha's artist books from the 1960s—such as *Some Los Angeles Apartments*, 1965—that present deliberately flat-footed and concept-driven investigations of mundane urban topographies. Yet beyond its amusing rhetorical conceit, McCormick's film is an intriguing visual investigation of Portland's urban and industrial landscapes, which it reframes as an entropic example of the picturesque. The film's slow pacing creates an urban ballet as the camera pans a barge's slow crossing or follows a cyclist dipping beneath underpasses and gliding past factories, the whirling of bicycle wheels accompanied by a minimalist electronic music sound track. McCormick's mock documentary is, finally, a lovingly rendered land- and soundscape that invites us to regard overlooked aspects of our built environment with a new sense of their aesthetic value. LC

Matt McCormick was born in 1972 in Washington, D.C. His films have been featured at the Sundance Festival (2002); San Francisco International Film Festival (2002); International Film Festival Rotterdam (2001); and both the Chicago and New York Underground Film Festivals (2000).

Portland

Matt McCormick
The Subconscious Art of Graffiti Removal (stills), 2002

Roy McMakin

Exploiting the tensions between art and design, form and function, Roy McMakin's practice places the usually separate creative activities of sculpture, architecture, and design in a tense equipoise. McMakin disconnects the language of forms from its usual contexts, demonstrating how meaning can turn on a dime through subtle shifts in perception. Although initially comforting, the familiar forms found in his objects—many of which reference the vernacular furnishings in his childhood home—are full of sly mischief. We readily identify a sconce, resembling a colonial candleholder, but discover that the light from this kitsch celebration of Americana comes not from its wooden bulb but from a nearby modern light fixture. Retaining vestiges of the functional, his works nevertheless confound our expectations.

For *Baja to Vancouver* McMakin has created five wooden benches to serve as seating for some of the video works in the exhibition. While impeccable handcraftsmanship and spectacular finishes draw attention to the woods used—signaling that these are not ordinary, utilitarian museum benches—visitors are, nonetheless, invited to sit on them. Surreal gray "ghosts" of these viewing benches intervene unexpectedly in the other galleries, suspended from the ceiling, protruding from a wall, or jutting at an angle from the floor. While their highly polished surfaces resemble metal, they are, in fact, constructed from the same woods as the "functional" benches and with the same meticulous attention to detail. As the once familiar objects reveal their unconventional properties (the ability to adhere to walls, for example), they emphatically refute their functional role, making a case instead for their acceptance as abstract, aesthetic forms.

McMakin's company, Domestic Furniture, is currently based in Seattle; its attendant workshop employs twenty people who collaborate in the painstaking and labor-intensive process of executing the designs. Well acquainted with the politics and practices of the logging industry as well as efforts to revitalize the ravaged landscape, McMakin uses new, less endangered woods and incorporates "faults" (knots, fissures, inconsistencies of grain) into his pieces to minimize waste. McMakin's commitment is as much to sustainable industries as to sustaining the local craftsmanship that, in the prefab, pressed-wood world of IKEA, is rapidly becoming as endangered as his materials. It is the underlying integrity of McMakin's production process, the covert idealism embedded in fabrication, that gives the visual puns activated by subtle juxtapositions of forms, finishes, materials, and historic references their aesthetic gravitas and ideological substance. LC

Roy McMakin was born in 1956 in Lander, Wyoming. He studied at the Portland Museum Art School (1975–7) and received both a BA (1979) and an MFA (1982) from the University of California, San Diego. *A Door Meant as Adornment*, a major survey of his work, was organized by the Museum of Contemporary Art, Los Angeles, in 2003. In addition, McMakin has completed numerous architectural, public art, and design commissions in the United States, notably for the J. Paul Getty Museum (1997) and the Museum of Contemporary Art San Diego (1995).

Seattle

Above
Roy McMaki
Untitled (Wood benches), 200

Previous page
Untitled (detail), 200

Roy McMakin
Untitled, 2003
(from top to bottom:
Hanging bench
On-end bench
On-wall bench
Sloping bench
Upside-down bench)

Mark Mumford

Mark Mumford creates text-based images from commercially made vinyl lettering applied directly to gallery walls. The texts, derived from everyday speech, are composed of words and phrases that hum or resonate. They make us more conscious of the space we inhabit as a shifting context where new meanings are constantly born, converge, and are displaced. Visually bold and austerely humorous, the texts contrive a situation where, in the artist's words, "meaning hovers on the threshold of realization.... They are, in essence, Neo-Pop paintings that pit spatial syntax against linguistic syntax, and in so doing, provide gallery visitors with a chance to fully experience the blinding noise that words alone create."

The exact placement of each word of Mumford's texts is critical. In *We Are All in This Together*, 2002, the long sentence is positioned at the level of the human voice box. We read the text but also experience the piece in relation to our bodies. The text may also be read as the horizon line of a landscape painting. From a distance one looks at a black line whose meaning transforms the gallery space, in the mind's eye, into an endless and sublime panorama. Thus the private space of text enters shared, architectural space where it is converted into public sculptural experience.

How the public and private grid intersect and create new meanings lies at the heart of *Nothing Ever Happened Here*, an ongoing performance work begun in 1996 when Mumford started putting up signs to mark places of personal or historical significance. Poking sly fun at the markers that designate historic sites, Mumford draws attention to the fact that there is, of course, no place on earth where nothing has ever happened.

At the MCA San Diego, a new text work, *Hold Still*, is positioned on windows overlooking the sea in a gallery associated with West Coast artist Robert Irwin's installation *1° 2° 3° 4°*, 1997. Like Irwin's work—a site-specific installation that literally opens up the galleries to the seascape beyond—Mumford's work connects conceptual practice to grand landscape painting. Irwin's piece invites one to pause and enter the realm of bodily sensation, of subtle shifts in air pressure, moisture, smell, and sound, whereas *Hold Still* connects the body to the unconscious yearning of photography. "Don't move!" we are told when our picture is being taken so as to still us, and, more profoundly, to still time.

Unlike Irwin's piece, *Hold Still* remains, like all of Mumford's text sculptures, locked in the realm of language. We enter the quagmires of his texts and emerge with the realization that stopping the flow of meaning is no more possible than trying to stop the inevitable flow of natural forces. LC

Mark Mumford was born in Wilmington, Delaware, in 1959 and received a BA from Kenyon College in 1981. He has had solo exhibitions at venues including Esther Claypool Gallery, Seattle (2002); James Harris Gallery, Seattle (2000); and the Henry Art Gallery, University of Washington, Seattle (1995). His work has also been presented in group exhibitions including *Cheap Thrills*, Henry Art Gallery, University of Washington, Seattle (2002); *Seattle Collects Seattle*, Seattle Center Art Pavilion (1997); and *The Written Word*, Radix Gallery, Phoenix (1994).

Seattle

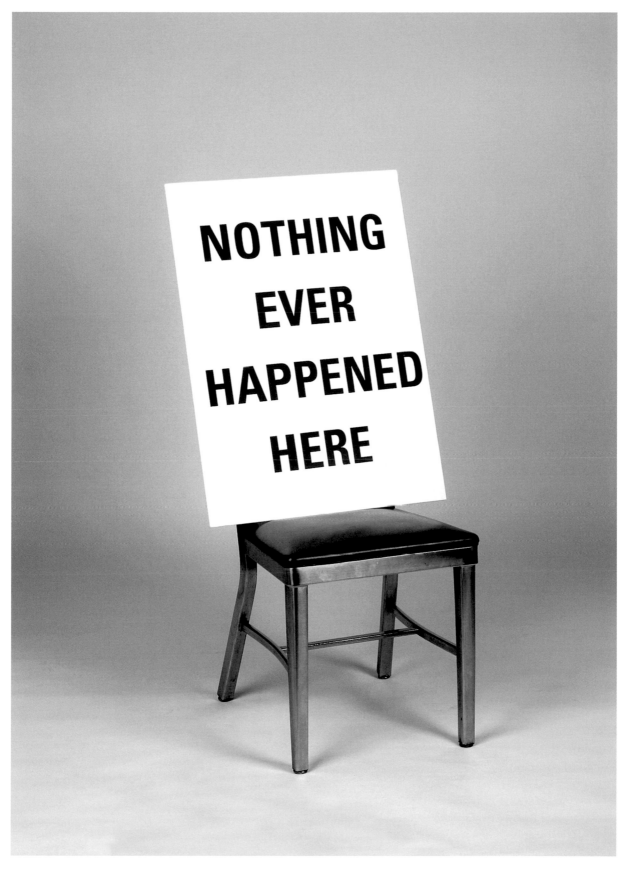

Mark Mumford
Nothing Ever Happened Here, 1996–ongoing

Shannon Oksanen
& Scott Livingstone

Apart from their practices as individual artists, Shannon Oksanen and Scott Livingstone have played together in bands and collaborated in producing video works and photographs. In many of their projects, including their DVD *Vanishing Point*, 2001, they employ their respective skills as artists and musicians in investigating the legacies of youth culture.

Inspired by the cult classic film *Vanishing Point*, 1971, Oksanen and Livingstone have remade a flashback scene from this counterculture road movie, a mock epic chronicling an antihero's car chase across the American West. In contrast to the original, in which speed, adrenaline, death, and groovy music prevail, Oksanen and Livingstone's *Vanishing Point* is melancholic and ironic in tone. Shot in 8 mm film on Long Beach, an unspoiled ten-mile stretch of sand on the remote western edge of Vancouver Island, it mimics the simplicity of a home movie. Comprised of a single stationary shot of the cold grey ocean, it shows us nothing more than an upside-down surfboard being washed ashore in an endless succession of waves.

It is a surprisingly forlorn spectacle. Caught in the incoming surf, the solitary board reads as a surrogate for the human body while evoking its mysterious, even ominous absence. Grainy images of the board's rhythmic drifting are accompanied by a rock sound track that—played by a pared-down guitar-drum duo—evokes the nostalgia-inducing riffs of pop surf music. The repetitive nature of the music is matched by the film's cyclical structure, which leaves us unsure where the action begins or ends and defies our desire for narrative resolution. Within this seamless loop, the bubble of the endless summer and an idealized youth culture has burst.

While minimal in its format, *Vanishing Point* summons the great tragedies of undelivered utopian ideals so often associated with the West Coast of North America, where the youthful hope and enthusiasm that generated westward journeys often vanish. In selecting Long Beach as their location, Oksanen and Livingstone also engage with the history of how the mass media, as well as artists, have represented the majestic natural environment of the Pacific Northwest. Though it is undoubtedly lyrical, *Vanishing Point* is hardly a Romantic homage to the sublime; instead, it recasts its subject as a played-out scene redolent of loss and lack of purpose. And by linking our perception and interpretation of this seascape to memories of pop music and cinema, the artists remind us that no image of nature, no matter how pristine, is ever innocent of culture. DA

Shannon Oksanen was born in North Vancouver, British Columbia, in 1967 and studied at the University of British Columbia. She has had solo exhibitions at venues including Or Gallery, Vancouver (2002) and VTO Gallery, London (2001, 1999). Her work has also been included in the group exhibition *Hammertown: Eight Artists from Canada's West Coast*, The Fruitmarket Gallery, Edinburgh (2002 and touring).

Scott Livingstone was born in North Vancouver, British Columbia, in 1968 and received a diploma in fine arts from Emily Carr College of Art and Design in 1988. Since 1986 he has performed with various bands throughout North America, including The Evaporators, Thee Goblins, Italy World, and The Tentacles.

Oksanen and Livingstone's collaborative works have appeared in *Pop Covers (Music and Landscape)*, Western Front, Vancouver (2001), and *These Days*, Vancouver Art Gallery (2001).

Vancouver

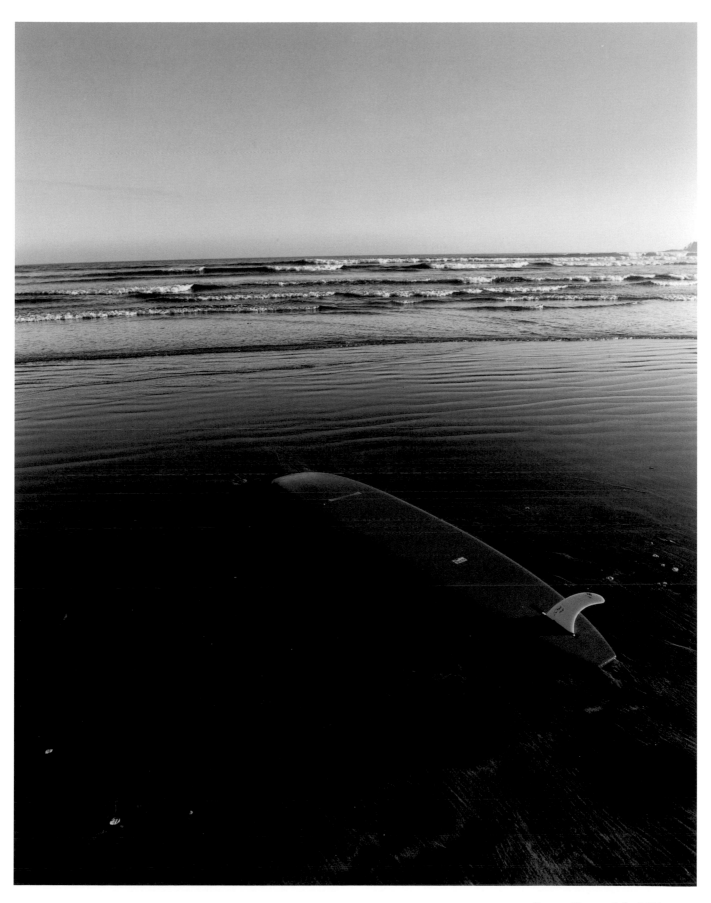

Shannon Oksanen & Scott Livingstone
Vanishing Point (production still), 2001

Michele O'Marah

From the outset of her artistic practice Michele O'Marah has been fascinated with the mechanics and machinations of popular culture and the mass media. In video works such as *Valley Girl*, 2002, and *White Diamonds and Agent Orange*, 2001, O'Marah draws on an informal cast of friends and fellow artists to reenact iconic moments from film and television's recent past. Though noteworthy for their word-for-word, scene-by-scene fidelity, O'Marah's remakes are hardly respectful of her source materials, but instead employ humor, parody, and irony as pointed tools with which to interrogate media stereotypes and clichés.

White Diamonds and Agent Orange is a two-channel video installation that incorporates two separate narratives whose respective images and sound tracks compete for our attention. One monitor displays a restaging of a *60 Minutes* television interview, circa 1970, with the actors (and then-spouses) Elizabeth Taylor and Richard Burton; the second monitor shows a pastiche of Hollywood Vietnam War epics such as *Apocalypse Now* and *Full Metal Jacket*. Seemingly unrelated, both narratives in fact represent different forms of conflict as entertainment: the tempestuous interaction of Taylor and Burton (who boozily tear into each other) and the unfolding drama of Vietnam, the first war to be played out in American homes through television broadcasts.

In each of these productions little attempt has been made to contrive a sense of realism. O'Marah has merely done enough, through the use of limited props and period costume, to establish a sense of the original. (North Vietnamese soldiers, for example, are portrayed by a largely Caucasian cast wearing conical hats and eyeglasses printed with squinting eyes.) With their self-consciously hokey and somewhat self-deprecating style, O'Marah's reenactments ultimately focus our attention on the artifice of the original television broadcasts and movies on which they are based.

While the juxtaposition of a Hollywood confessional and a cartoonish gun battle hardly seems unusual—this has long been standard fare for a night of television—the amateurism of the performances in O'Marah's work serves to distance viewers, underscoring the surrealism of the American media diet. *White Diamonds and Agent Orange* is both a satire on, and a metaphor for, our present media landscape with its fixation on news as entertainment and entertainment as news. Juxtaposing Taylor and Burton's domestic conflicts with the realities of a brutal and ultimately futile war, O'Marah crystallizes the contradictory impulses and nature of the American psyche, in which a prurient fascination with celebrity sits uneasily alongside a parallel obsession with violence. TK

Michele O'Marah was born in Vallejo, California, in 1967 and received a BFA from the Tyler School of Art in 1991. She has had solo exhibitions at Goldman Tevis Gallery, Los Angeles (2002), and The Void, New York (1998). Her work has also been included in the group exhibitions *Play It As It Lays*, Institute of Contemporary Arts, London (2002); *Video Projects*, Galleri Nikolai Wallner, Copenhagen (2001); and *We Love Aaron Spelling*, Knitting Factory, New York (1996).

Los Angeles

Michele O'Marah
White Diamonds and Agent Orange (stills), 2001

Marcos Ramírez ERRE

Marcos Ramírez, whose diminutive ERRE derives from the Spanish pronunciation of the letter R, makes work that examines language, place, and human aspirations. His paintings, sculptures, and large-scale public artworks illuminate politically charged situations, often expressing the complexities of working as an artist on both sides of the Mexico-U.S. border. For INSITE 1997, a public art exhibition in Tijuana and San Diego, for example, Ramírez constructed a giant two-headed wooden Trojan horse that straddled the official national boundary line at the busy San Ysidro border crossing. A potent symbol of illicit entry and cultural imperialism facing both north and south, the sculpture's bidirectional stance asked the question, "Who is invading whom?"

Ramírez has been making signpost works since the 2000 Havana Biennial, for which he created a work that paired international cities such as Jerusalem with germane quotes such as "Thou shalt not kill." The work poignantly drew attention to the plight of Cubans, who are prevented from traveling internationally, and suggested a new, critical way of considering a globalized world. Commissioned to make a work for *Baja to Vancouver*, Ramírez has created *Crossroads (Tijuana/San Diego)*, a twelve-foot-high orientation sign with markers pointing the way from the Mexico-U.S. border to ten West Coast and international cities. Aligned according to the appropriate compass direction, each sign bears the name of and distance to its respective city on one side and a statement by an influential resident artist on the reverse. Examples include: Vancouver 1,891 km/*Transgression is the beginning of authentic existence.*—Jeff Wall; and Paris 9,160 km/*The only works of art produced by America are its plumbing fixtures and its bridges.*—Marcel Duchamp. Appropriating the style of official street signs and tourism markers, Ramírez attempts to chart a complex international psychogeography, using the West Coast as his starting point. While the signs point the way to a conceptual globalism, the thoughts they proclaim underline Ramírez's belief in the continuing validity of the artist's critical role. TK

Marcos Ramírez ERRE was born in 1961 in Tijuana, Baja California. He studied law at the Universidad Autónoma de Baja California and painting in the studio of Alvaro Blancarte. Ramírez has had solo exhibitions at Intersection for the Arts, San Francisco (2002); the Museum of Contemporary Art San Diego (1999); and the Institute of Visual Arts (Inova), University of Wisconsin–Milwaukee (1999). He has also participated in numerous group exhibitions, including the Havana Biennial (1997, 2000); the Whitney Biennial (2000); and INSITE San Diego/Tijuana (1994, 1997).

Tijuana

Marcos Ramírez ERRE
Crossroads (Tijuana/San Diego), 2003

Glenn Rudolph

Traveling like a nomad in an old truck with his Leica camera and canine companion, Glenn Rudolph photographs the urban, suburban, and rural landscapes of the Northwest. Tracking his subjects over the course of several decades, Rudolph has sought out what is vanishing, abandoned, and overlooked as sprawling growth overtakes the region. His photographs have explored the archaeological remains of the Northwest's former railroad culture with its disused tunnels, tracks, and trestles; the activities of migrant workers and hobos, Native Americans, and urban youth tribes; and the last vestiges of untouched nature as it collides with man-made environments. His images of the people and places of the Northwest often examine the interstices of city and country, industry and wilderness, undermining romantic illusions of the region as a social and ecological utopia.

Rudolph's professed interest in the transitional, ever-changing light of the Northwest is evident in many of his works—such as *Trailer, Stampede Pass*, 2000, in which the light breaking through an otherwise ominously cloudy sky picks out a trailer huddled in a vertiginous mountain pass. While the image of a solitary human dwelling dwarfed by a majestic landscape is a traditional trope of the sublime, Rudolph's image is disturbing rather than awe-inspiring, as the trailer is surrounded by a vast forest of electrical poles rather than Douglas firs. The landscape surveyed here is an uncertain hybrid, a disconcerting conflation of nature and industrial society.

The inclusiveness of Rudolph's photographic project recalls Eugene Atget's comprehensive documentation of a "disappearing" Paris. His work also shares Diane Arbus's eye for the eccentric, bordering on the surreal. *Cherry Picker, Priest Rapids*, 2001, portrays a long-bearded migrant worker staring into the sun with a mad Biblical grandeur at odds with the remnant of modern living, a broken-down lawn chair, that he leans on. In *Red Blanket, The Order of the Falcon, Kent*, 2001, Rudolph presents an apocalyptic version of Edouard Manet's *Déjeuner sur l'herbe*, 1863: a woodland picnic featuring young people in black goth clothing, surrounded by the plastic relics of a throwaway culture.

But perhaps the historical precursors most closely related to Rudolph's work are nineteenth-century frontier photographers such as Carleton Watkins and William Henry Jackson, who documented the logistics of the developing West. More than a century later, Rudolph chronicles the transformed countryside and spoiled utopias of the new frontier and shows us how the people living there adapt to its landscape of constant change, parading in the rains of ruin. LC

Born in Los Angeles, California, in 1946, Glenn Rudolph received a BFA from the University of Washington in 1968. He has had solo exhibitions at the Seattle Art Museum (1986); Bellevue Art Museum, Bellevue, Washington (1977); and The Phillips Collection, Washington, D.C. (1976). He also has participated in numerous group exhibitions including *Naked in the Landscape*, Pace/MacGill Gallery, New York (2002); *Hereabouts: Northwest Pictures by Seven Photographers*, Seattle Art Museum (1999); and *Track Records: Trains and Contemporary Photography*, Canadian Museum of Contemporary Photography, Ottawa (1997).

Seattle

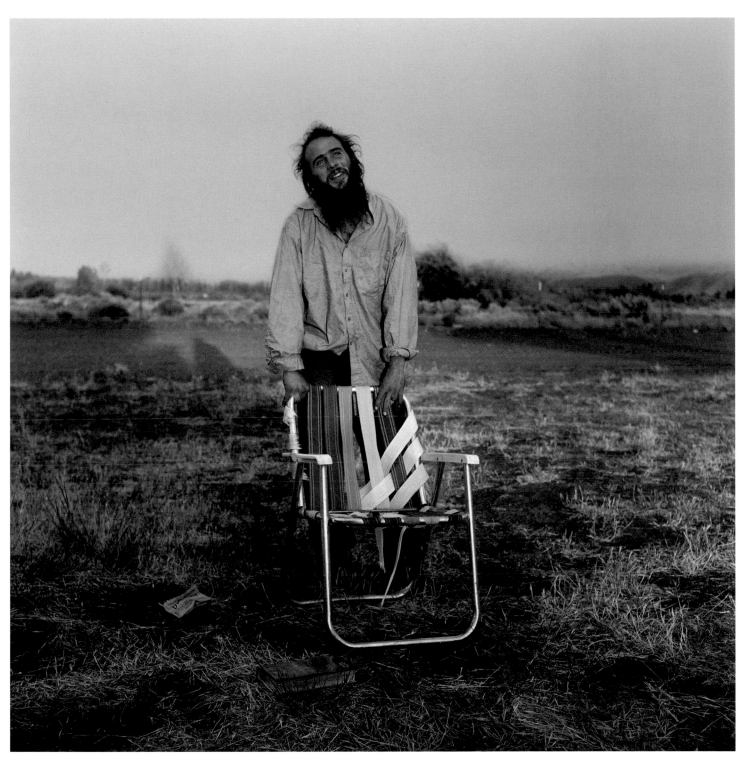

Glenn Rudolph
Cherry Picker, Priest Rapids, 2001

Glenn Rudolph
Trailer, Stampede Pass, 2000

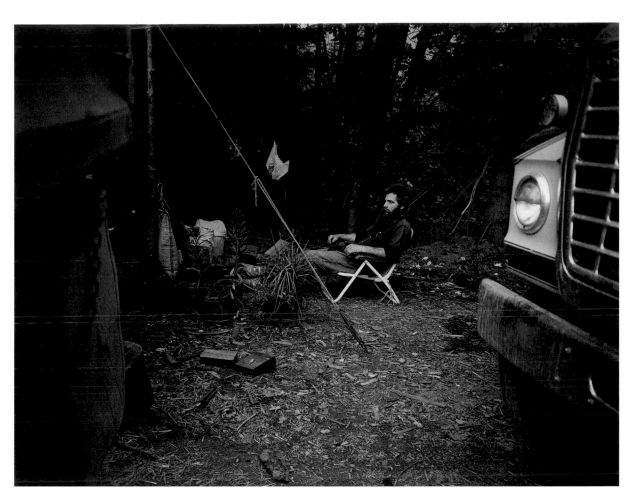

Glenn Rudolph
Security Guard, Stampede Pass, 1998

Steven Shearer

Steven Shearer works simultaneously on discrete but interrelated bodies of work, in which the often debased and sometimes deviant mannerisms of adolescent cultural forms collide with the progressive ideas and desires of modernism. Working across a wide range of media, including painting, sculpture, photography, and installation, Shearer displays both an affection for and an affectation of the cut-and-paste look of early-1970s teen pop fanzines. These publications, owing to their primitive design sense, low budgets, and indiscriminate mixing of professional and amateur photography and graphics, created a unique scrapbook-style aesthetic that appears as a vulgar riff on the avant-garde collage. In earlier works Shearer conflated seemingly disparate material—such as found photographs of blue-collar suburban rock fans, images of late-1960s modular play areas, and reproductions of the crudely rendered children's craft art popularized in the late 1950s—into unholy yet elegant cosmologies that bring to mind the social and (sub)cultural scavenging of Richard Prince or Mike Kelley.

In more recent works such as the ongoing *Metal Archives*, 2001–, and *Guitar*, 2002–, series, Shearer's lexicon of imagery has become more focused and rigorously defined. The *Metal Archive* and *Guitar* works are large-scale inkjet prints of roughly schematic grids, each created from several hundred postage stamp-size pictures largely captured from the online auction site eBay or from individuals' homepages. Documenting a minute fraction of the shifting inventory of images on the web, Shearer is ultimately interested in the quasi-anthropological account of the various subcultures that these homemade images afford. For Shearer the heavy metal memorabilia and amateur guitarists are not only products of the music and culture industries, but also symbols of and participants in a proletarian folk art.

The domestic interiors subliminally registered in the backgrounds of the *Metal Archive* images—details that reveal the socioeconomic status and lifestyle of the heavy metal enthusiasts—are more forcibly apparent in works from the *Guitar* series. For these Shearer has again surfed hundreds of homepage picture galleries in search of images of people either playing or showing off their guitars. What emerges is a male-dominated activity played out in countless suburban bedrooms, living rooms, gardens, basements, and dens. A lapsed virtuoso metal guitarist himself, Shearer infects these mazelike grids of anonymous players with images of himself as a teenager proudly posing with his own guitars. In associating his own adolescent desires with the collective rock star fantasies of these virtual communities, Shearer establishes a tension between the autobiographical and the anthropological. In doing so he frustrates our desire to read or dismiss his appropriation of these ostensibly "low" images as being a merely ironic or condescending gesture. MH

Born in New Westminster, British Columbia, in 1968, Steven Shearer received a BFA in 1993 from Emily Carr College of Art and Design. He has had solo exhibitions at Blum & Poe, Los Angeles (2003); Mars Gallery, Tokyo (2002); and American Fine Arts Co., New York (2002). His work has also appeared in group shows including *I See a Darkness*, Blum & Poe, Santa Monica (2003); *Rock My World: Recent Art and the Memory of Rock 'n' Roll*, CCA Wattis Institute for Contemporary Arts (2002); and *East International*, Norwich Gallery, Norwich, England (1999).

Vancouver

Right (detail) and overleaf
Steven Shearer
Guitar #5, 2002–

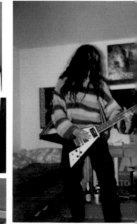

Catherine Sullivan

Catherine Sullivan's videos, photographs, and performances cross back and forth between theatre and visual art, using the latter as an arena for a formalist analysis of theatrical conventions. In *Five Economies (big hunt/little hunt)*, 2002, she sets up a comparative relationship between a large multi-screen video installation and an intimate single-channel work to investigate the mechanics of expression. Influenced by her acting instructors as much as by Elias Canetti's analysis of relationships of power, Sullivan adopts the model of a hunt in this work, exploring the rituals and limits of the inherent human impulse to escape being someone else's "prey." The premise is that the structure of the hunt prompts an actor's transformation into various psychological states as a means of dramatic survival. Under the heightened conditions of this pursuit, the video reveals the successes and failures of actors as they react to their circumstances and attempt to master the roles assigned to them. The result constitutes an exposé of the dramatic gesture and forces us to reconsider the contingency of theatrical meaning.

In *Little Hunt*, 2002, Sullivan has stripped away the emotional and narrative context used in other works and has left her two actors to interact with an arbitrary collection of props, including a rifle, a scythe, a coffin, and various houschold items from a dramatic production of Victor Hugo's *Les Miserables*. The actors, one trained in modern dance movement and the other in ballroom dancing, were asked to make these objects part of their choreographic gestures without the aid of any apparent rationale or story line. Set on a Los Angeles tennis court, their actions suggest an absurd *danse macabre* at times, testing our desire and capacity to assign meaning to physical behaviour. The video was shot over the course of a day and a night; its editing subversively tweaks the trope of continuity as a further challenge to theatrical expression. Yet despite its intentional disregard of narrative conventions, Sullivan's video allows us to recognize how codes of stage and cinema impact the theatre of everyday life, teaching us to repeat the gestures and stances we see in order to enact the necessary roles of our lives. DA

Catherine Sullivan was born in 1968 in Los Angeles, California. She received an MFA from Art Center College of Design in 1997. Her performances have been featured in festivals, theatres, and colleges internationally since 1994. She has had solo exhibitions at the Wadsworth Atheneum Museum of Art, Hartford, Connecticut (2003); Renaissance Society at the University of Chicago (2002); and UCLA Hammer Museum of Art, Los Angeles (2002). Her work has also been shown in group exhibitions and screenings at venues including Kunstverein Hamburg (2001); Museum Villa Stuck, Munich (2000); and Secession, Vienna (1999).

Los Angeles

Catherine Sullivan
Little Hunt (stills), 2002

Larry Sultan

Since the mid-1970s, photographer Larry Sultan has repeatedly examined aspects of suburban life on the West Coast, blending elements of documentary and staged photography to create images that explore psychological as well as physical landscapes.

In his ongoing photographic study *The Valley*, Sultan focuses on the San Fernando Valley's pornographic video industry. Rather than depicting the sensationalistic and the sexual, Sultan's shrewdly composed photographs underscore jarring incongruities in the production process, which often takes place in San Fernando McMansions rented for the day.

Chronicling intersections of the mundane with the outrageous or theatrical, these images evoke surprising correlations between the aesthetics of pornography and suburbia. Sultan himself has described the porn industry as an attempt to compensate for the diminished social life and pervasive denial of pleasure in suburbia. In foregrounding details of domestic sets—the faux-historical furnishings and decorations that embody class aspirations for luxury and propriety—Sultan also suggests a shared system of values. *Suburban Street, West Valley Studio*, 1999, which depicts a photographic backdrop of a banal tract neighborhood that hangs in a production studio, and *Cabana*, 2000, an image of an outdoor orgy seen through a backyard hedge, both capture the aura of middle-class domesticity pervading many pornographic fantasies.

This same incongruity animates photographs such as *Kitchen Window, Topanga Canyon*, 1999, and *Woman In Garden*, 2001, which respectively depict undressed male and female performers in private moments—a man looking out of a window and a woman talking on a cell phone in a backyard. In portraits such as these, Sultan conveys the unremarkable, everyday humanity of his subjects, who are nevertheless set apart by their casually professional and utterly unselfconscious nakedness.

Perhaps the photograph *Tasha's Third Film*, 1999, best represents the complexities of Sultan's enterprise. It shows us Tasha, a new actress, her hair in curlers, waiting on a couch flanked by two sleeping men—one of whom, creepily, naps with his eyes open. Behind her, and through a sliding glass door, we can see a camera crew filming a sex scene on a patio in front of a small group of spectators seated on plastic chairs. As Tasha gazes at Sultan's camera while waiting to be called for *her* next scene, we cannot help but wonder what will become of her as she continues her career. Highlighting an uneasy mix of fantasy, mundanity, and degradation, Sultan's demure yet voyeuristic photograph elegantly evokes the mixed emotions fueling our fascination with the porn industry and its products. TK

Born in New York City in 1946, Larry Sultan received a BA from the University of California, Santa Barbara, in 1968 and an MFA from the San Francisco Art Institute in 1973. His photographs have been featured in solo exhibitions at the San Francisco Museum of Modern Art (2004); San Jose Museum of Art (1992); and Fogg Art Museum, Cambridge, Massachusetts (1978). Sultan's work has also appeared in group shows including *Contemporary American Photography*, Samsung Museum of Modern Art, South Korea (2002–3); *Visions from America: Photographs from the Whitney Museum of American Art* (2002); and *Chic Clicks*, Fotomuseum Winterthur, Switzerland (2002).

Greenbrae

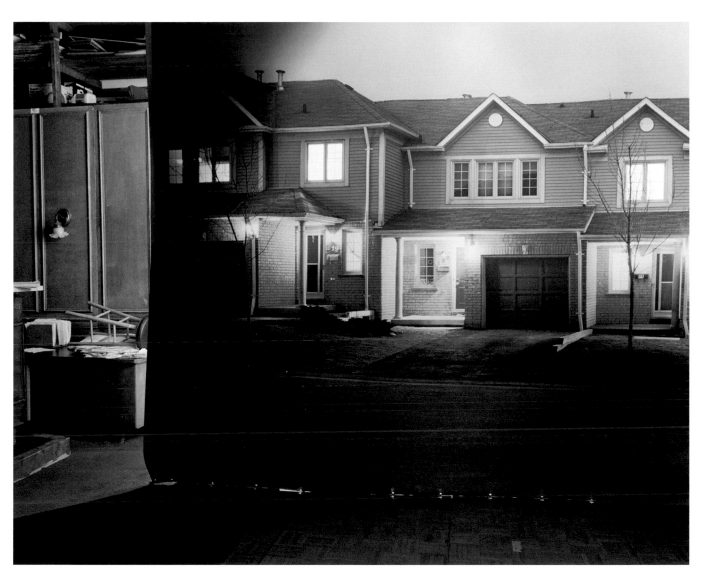

Larry Sultan
Suburban Street, West Valley Studio, 1999

Larry Sultan
Kitchen Window, Topanga Canyon, 1999

Larry Sultan
Cabana, 2000

Ron Terada

Ron Terada employs various components of exhibition-making in his art, including advertising posters, interpretive brochures, and gallery signage. Increasingly, his work has addressed the underlying premises of specific art exhibitions, playing with their institutional intent and curatorial theses, as well as the expectations of the viewer. As part of this body of work, Terada has created sign works that can be interpreted through a variety of filters, be it the discourse of painting, the Duchampian engagement with the ready-mades of popular culture, or the influence of poststructuralist thought. Ranging from a sign painter's subtle extension of an art gallery's corporate identity to neon signs serving as exhibition titles, these industrially produced artworks typically possess a performative aspect.

Always preoccupied with the importance of location, identity, and context, Terada has taken on the representation of his native city in his latest works. As a Vancouver-based artist of growing repute, Terada has been included in various group exhibitions featuring an emerging generation of artists who are beginning to supersede the "Vancouver School" (as exemplified by photo-conceptualists such as Jeff Wall, Ian Wallace, Ken Lum, and Rodney Graham). As these exhibitions are organized farther and farther from Vancouver, Terada has become interested in delivering the curatorial parameters of his selection in the very structure of his work and has adopted an obvious symbol of Vancouver—the city sign—for his content and his form.

Terada first used this image as a photograph on a poster advertising a Vancouver-based exhibition, then as an art magazine ad for his dealer's gallery; in both cases his works functioned as a representation of the exhibition while also constituting his contribution to the exhibition. In an ultimate gesture of appropriation, Terada contracted Vancouver's official signmakers to build him an exact replica of the roadside sign that announces the city limits.

When placed in galleries and museums, Terada's ten-by-ten-foot artwork, *Entering City of Vancouver*, 2002, no longer, of course, welcomes visitors to an urban centre; instead, it conjures the dubious practice of branding art by region. It also makes a conceptual nod to N.E. Thing Co., a collaborative duo whose practice through the 1960s and 1970s often involved claiming certain banal public sites as art. In a similar vein, Terada's work could be seen as conceptually claiming the entire city as his ready-made. But by recontextualizing this city sign, Terada also raises questions not only about the packaging of artists as part of a regional identity, but about the limits to our conventional representations of urban identities. DA

Ron Terada was born in Vancouver, British Columbia, in 1969 and received a diploma in fine arts from Emily Carr College of Art and Design in 1991. His solo exhibitions and projects include *Catalogue*, Contemporary Art Gallery, Vancouver (2003); *Defile*, Art Metropole, Toronto (2003); and *Present Tense*, Art Gallery of Ontario (1998). His work has also appeared in group exhibitions including the Prague Biennial (2003); *Art Music: Rock, Pop, Techno*, Museum of Contemporary Art, Sydney (2001); and the Melbourne International Biennial (1999).

Vancouver

Althea Thauberger

Althea Thauberger's works often begin when she publishes her own open-call advertisements in local newspapers. She auditions applicants, and those she casts become collaborators in the realization of her projects. Parents answered her ads for baby models born in the days just prior to one of her shows (*New Day Jubilee*, 2002). Another casting call yielded a performance combining amateur and professional entertainers before a live audience in a makeshift television studio set up in a gallery (*Dream Factory*, 2002). Young girls vied with one another to be featured on a billboard mural that would transform the winner into a local celebrity (*Steffanie Davis*, 2003). Once she chooses her collaborators, Thauberger appropriates the tactics of professional image-makers with a gentle touch. Indeed, it needn't be otherwise. Her subjects have so thoroughly absorbed the mass-media language of stardom that they effortlessly metamorphose into "stars."

The *Songstress* project began in spring 2001 with Thauberger's ad seeking young female singer/songwriters, placed in *Monday Magazine*, Victoria's weekly entertainment magazine. The resulting work is a series of eight unedited three-minute music videos, each created in a single take on 16 mm film. The videos feature fresh-faced women aged between fifteen and twenty-seven lip-synching to a recording of one of their own songs, selected, for the most part, and produced by Thauberger. The songstresses chose their flowing outfits and choreographed their dramatic gestures, with guidance from the artist. Their musical styles vary from wistful hippie-folk and New Age positivism to angry girl ballads; the images they project are derived from immediately recognizable female music world icons such as Joni Mitchell.

Thauberger selected arcadian locations for the videos. The grassy meadows, lakeside overlooks, and evergreen forests echo perfectly the sentimental emotional landscapes of dreams, hopes, yearning, and awe, expressed in the deeply personal, often melancholy lyrics. They capture the ideals that characterize the Romantic vision of the West Coast as a pastoral world offering spiritual enlightenment and freedom through an immediate connection with nature.

Seen consecutively, the videos give rise to conflicting responses. Do we empathize with the feelings of vulnerability the songstresses express? Do we titter at the predictability of the unwitting parodies of their musical icons? Or, despite the idyllic locations, their ethereal appearances, and the apparent emotional directness of their music, is their earnestness merely crudely disguised ambition? Thauberger constructs stages for her performers to play out the human desire to "be somebody" and for us, the audience, to examine the ambivalent feelings we experience watching them become complicit with, in Joni Mitchell's words, "the star-maker machinery behind the popular songs." LC

Althea Thauberger was born in 1970 in Saskatoon, Saskatchewan. She received a BFA from Concordia University in Montreal in 2000 and an MFA from the University of Victoria in 2002. She has had solo exhibitions at La Centrale, Montreal (2003); WARC Gallery, Toronto (2003); and the Art Gallery of Greater Victoria (2002). She has also been in group exhibitions including *Swoon*, Richmond Art Gallery, Vancouver (2003); *Satan, oscillate my metallic sonatas*, Contemporary Art Gallery, Vancouver (2002–3); and *Proof 9*, Gallery 44, Centre for Contemporary Photography, Toronto (2002).

Vancouver

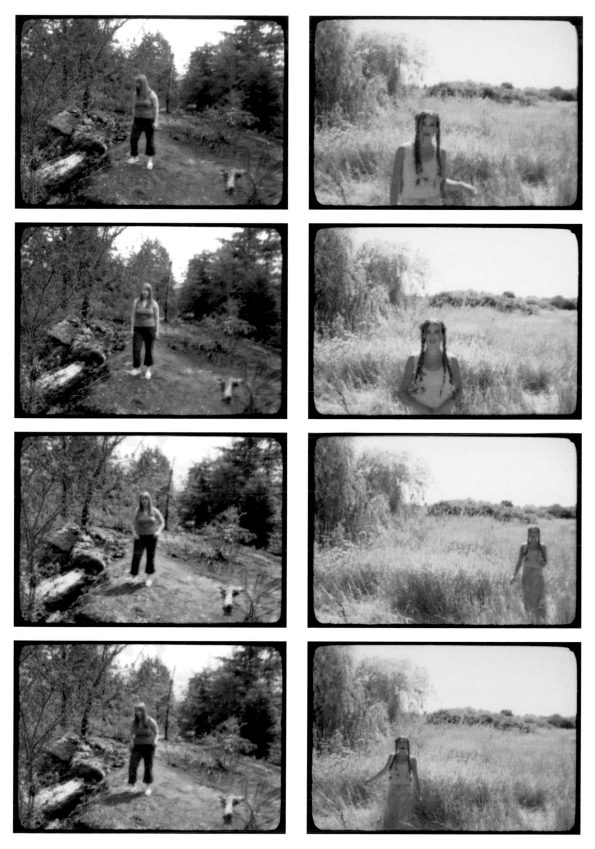

Althea Thauberger
Songstress (stills), 2001–2

Torolab

Torolab—its name a play on the Spanish words for bullfighting and laboratory—was established in 1995 as a socially engaged workshop committed to examining and improving the quality of life for residents of Tijuana and the entire California–Baja California border region through a culture of ideologically advanced design. Incorporating furniture, clothing, and architectural and graphic design, Torolab's projects include plans for affordable, easily constructed "emergency architecture" envisioned as dwellings for Tijuana's poorest residents. Their clothing line Torovestimenta includes a range of multipurpose garments intended as functional, problem-solving "gear for living," such as their Transborder Pants, trousers with hidden pockets the size of Mexican passports and the valuable and difficult to replace U.S. "laser visas" prized by regular border crossers from Mexico. Torolab has also developed a vibrant graphic aesthetic built around the influential Nortec music movement, which blends global techno beats with traditional northern Mexican *norteño* sounds. Their *Vertex Project*, meanwhile, is an architectural model for a border-crossing footbridge-cum-multimedia environment that proposes to humanize the experience of crossing between cultures by presenting stories by and about migrants.

Offering concrete responses to social conditions in Tijuana—a booming, sprawling city of over one million residents—Torolab's projects are driven by their pragmatic, change-oriented ethic that it is "better to propose than to protest." In its utopian quest for the sublime in the quotidian, for finding elegant solutions to everyday problems, Torolab also draws on art and literature as primary tools in all its projects, including its manifesto-emblazoned T-shirts. Their contribution to this catalog (see p. 120), for instance, outlines the group's perspective on the problems and potential of the transborder region in images and text.

Torolab's *Urban Survival Unit*, 2002, a portable dwelling for Tijuana's homeless, is featured in the exhibition itself. The *Urban Survival Unit* is a collapsible tent designed to fit in the hidden spaces behind and between the billboards that pepper the Tijuana landscape. Packaged in a cleverly constructed and attractive hexagonal backpack, the *Urban Survival Unit* represents an absurd solution to an obscene problem. (Because of its extreme poverty and high crime rate, Tijuana is a more dangerous and hostile environment than most U.S. cities.) Mixing irony and optimism, this self-contained camouflaged dwelling highlights an enormous and pernicious social problem while also reinventing and resuscitating the social idealism that distinguished much modernist art, architecture, and design. TK

The founders and principals of Torolab are Raúl Cárdenas Osuna, born in Mazatlan, Sinaloa, in 1969, and Marcela Guadiana de Cárdenas, born in Mexicali, Baja California, in 1970. Both received degrees in architecture from the Universidad Autónoma de Baja California in 1994. Their solo exhibitions include *Torolab: Laboratorio of the Future in the Present*, Museum of Contemporary Art San Diego (2001), and *SOS*, Cedille, Paris (2002). Their work has also been included in the group exhibitions *Transmediale 0.3*, a media art festival in the House of World Cultures, Berlin (2003); the Montreal Biennale (2002); and *Utopia Now*, CCA Wattis Institute for Contemporary Arts (2001).

Tijuana

Torolab
Urban Survival Unit, 2002

Yvonne Venegas

The daughter of a society wedding photographer, Yvonne Venegas has described her father as dedicating his life to the art of appearances, inventing through his work a perfect world that people buy for their memories. Borrowing its title from the legend emblazoned above her father's studio door, Venegas's ongoing series *The Most Beautiful Brides of Baja California*, 2000–, draws on the conventions of commercial portrait and event photography to present glossy outtakes—high-quality images of the anomalies and fissures in seemingly perfect existences.

Her access often guaranteed by her position as friend and relative, Venegas attains an intimate proximity, frequently catching her subjects off guard at showers, at parties, or with their children. Whilst it may not be Venegas's intention to criticize—and indeed the commentary of some of her documentation is subtle almost to the point of ambiguity—her observations are a compelling argument for appearances belying reality. A striking image of the individual at odds with her surrounds, *Maribel en su despedida de soltera*, 2001, captures the bride-to-be among her friends. Significantly, Maribel alone faces the camera, which registers her face, contorted by some small annoyance or worry, creating a tension between the brightly lit room and her unease. Venegas's sensitivity to the ironies of such situations is present in images such as *Bandera y Veronica*, in which a young girl poses for the camera unselfconsciously as her mother stares at the photographer. In the woman's eager gaze lies an appreciation of the camera's power to create perfection, while the little girl's enjoyment of her moment in the spotlight takes on a poignancy in view of her unawareness that she is about to lead life in its glare.

While Venegas's photographs often display an almost willful disregard of compositional conventions—as in *Parejas*, 2002, which depicts two couples foregrounded and pushed towards the right edge of the image—many of her works take on a rigorous formality that further enhances their meaning. The subject of *Yordana*, 2001, descending a staircase in her bridal finery, is framed in a gilt mirror, a device that transforms the woman into a cipher, presenting her as a reflection and not the embodiment of happiness. In *Anette y Lizette*, 2001, the self-conscious poses of the two sisters ensconced in a comfortable living room seem at odds with the dissatisfaction and ennui evident in their expressions.

Venegas's focus on the rituals, protocols, and proprieties of relatively affluent subjects is all the more potent in the context of Tijuana—long stereotyped as a one-dimensional factory town that doubles as a tawdry playground for U.S. sailors. Thus her photographs document what is in effect an emerging social stratum, conveying the recognizable class aspirations of the newly arrived. LC

Yvonne Venegas was born in 1970 in Long Beach, California. She attended the General Studies Program at the International Center of Photography in New York. Venegas has had solo exhibitions at the Museum of Contemporary Art San Diego (2003); the Centro Cultural Tijuana (2002); and Centre VU, Quebec (2002). Her work has also appeared in the group show *Lines of Sight: Views of the U.S./Mexican Border* at the Sweeney Art Gallery, University of California, Riverside (2002). In 2002 her work won top honors in the Bienal de Fotographia, Centro de la Imagen, Mexico City.

Tijuana

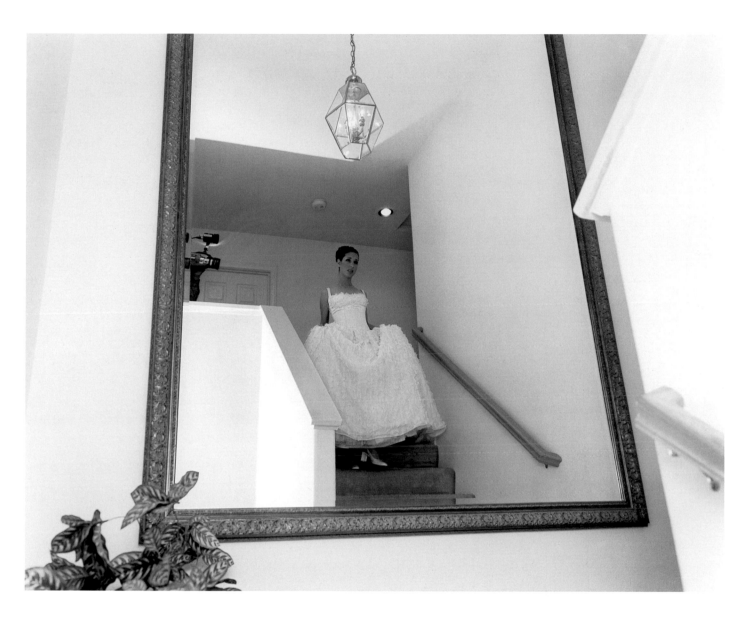

Yvonne Venegas
Yordana, 2001

Yvonne Venegas
Anette y Lizette
(Anette and Lizette), 2001

Maribel en su despedida de soltera
(Maribel at Her Bridal Shower), 2001

Yvonne Venegas
Bolsa de Sabritas (Chips Bag), 2002

VIEWS FROM THE WEST COAST

Movement and velocity

Movement and velocity >>>> These are the patterns we constantly perceive when we look at Tijuana. It is difficult to imagine this transborder environment as a city. There is nothing to compare it to in Mexico, Latin America, or anywhere else in the world. As a case study, it is a unique phenomenon among transborder regions because of its socioeconomic contrasts and temporal-cultural conditions.

Movement with velocity >>>> "But all I want is to cross that damned street!" We understand the objective through extremes of the subjective, and also through situations (1), says anthropologist Fiamma Montezemolo of the Colegio de la Frontera Norte. Crossing a street always changes one's attitude (in relation to the city) about how to negotiate your place within what should be a democratic scheme of urban mobility. What happens when this negotiation takes place in the city that has the most cars per capita in all of Latin America and in the world? (According to the statistics of the Tijuana Department of Transit, there are 1.2 cars per person, including people who do not drive.) Nowadays, urbanity only travels by car.

Movement without velocity >>>> It seems—but only seems—like a contradiction.

In a city, streets were always the great equalizer. We all moved through them, and it was on the level playing field of the streets that we came to see how the higher classes lived. Today, in Tijuana, you can achieve this state of equality only if you can manage the expense of a vehicle—the expense, not only of the vehicle itself, but also the cost of maintenance in a city of driving challenges, a city of badly designed intersections, a city that is never finished paving its streets, a city whose cars form a tsunami of second-, third-, and fourth-hand vehicles salvaged from the United States. It is one thing to become the owner of a car, which may require a modest outlay of only two hundred dollars (or even less). It is another thing to be able to drive this car and maintain it, especially in such a chaotic vehicular environment, with the elevated risk of accidents, in a deteriorating social and urban environment.

Movimiento y velocidad

by: Raúl Cárdenas-Osuna/ Torolab

Movimiento y velocidad >>>> son patrones que se perciben constantemente, cuando vemos a Tijuana. Es difícil imaginar esta región transfronteriza como ciudad. No hay punto de comparación en la República Mexicana, Latinoamérica, u otro lugar del mundo. Como caso de estudio, es un fenómeno único entre los ámbitos fronterizos, por sus contrastes socio-económicos y sus condiciones temporales-culturales.

Movimiento con velocidad >>>> "pero si yo lo único que quiero es cruzar esa bendita calle" Lo objetivo siempre se entiende a partir de los extremos subjetivos y también de las situaciones (1), dice la antropóloga Fiamma Montezemolo, del Colegio de la Frontera Norte: el cruzar una calle cambia siempre tu postura (ante la ciudad) de cómo negociar tu lugar dentro de lo que debería ser un democrático esquema de movilidad urbana. Qué pasa cuando esta negociación se encuentra ante la ciudad que tiene más carros per-capita en Latinoamérica y una de las que tiene más en el mundo (deacuerdo a las estadísticas del Departamento de Tránsito del municipio de Tijuana hay 1.2 carros por persona, incluyendo a los que no manejan). Ahora la urbanidad sólo transita en automóvil.

Movimiento sin velocidad >>>> suena a cancelación, pero solo suena.

Las calles siempre fueron el gran espacio democratizante de las ciudades. Todos nos movemos sobre ellas, y por fin se abren los ejes que permiten observar como viven los de clases más altas, desde un plano de igualdad civil. Sólo que ahora en Tijuana se logra esto si pasas la costosa barrera del automóvil. Costosa al cabo, no por el costo del auto, sino de los gastos que acarrea conducir un mal auto, en una ciudad de difícil transito, con intersecciones, accesos y salidas mal realizadas, que nunca se termina de pavimentar, y donde los carros son en su inmensa mayoría un tsunami de recuperaciones de segunda, tercera o cuarta mano provenientes de Estados Unidos. Convertirse en el propietario de un automóvil, puede tener el módico costo tan solo de 200 dólares (y aun menos). Otra cosa es que el carro se encuentre en condiciones mecánicas para transitar, que el propietario este capacitado para conducirlo, o pueda solventar las responsabilidades que conlleva el hacerlo, especialmente en un medio vehicular tan caótico, son factores que elevan los riesgos de un accidente, y deterioran los medios social y urbano.

Pero con todo y todo >>>> los carros transitan. Y el movimiento se da a tal punto, que se convierte esta ciudad en la más visitada del mundo: 6,547,517 al año (2), en lo que es la frontera terrestre mas grande del mundo. Lo que no muchos mencionan es que gran parte (si no la mayoría) de estos visitantes son los mismos habitantes de esta región transfronteriza, que van a sus trabajos y luego regresan a sus casas de un lado u otro de la frontera.

Para los habitantes de lo que es la parte mexicana de esta región el carro no iguala si no que regula el cómo vivir y apreciar tu entorno. No se cuenta con un sistema funcional de transporte publico como en San Diego (que tampoco es de lo mejor, sobre todo por su excesivo costo) y las decisiones de diseño urbano y transporte se hacen a partir del transporte en automóvil individual. Entonces las calles dejan de ser para los peatones y las calles pierden su sentido histórico de lugar de encuentro social. Pero el encuentro si se da, solo que en mayor flujo de movimiento y a mayor velocidad.

Relaciones preceptúales de movimiento y velocidad >>>> los autos serán integradores y desasociadores sociales dentro de este entorno de supremacía urbana, pero esto también significa que adquieren un nuevo rol como agentes de percepción espacial.

La ciudad es un proceso interminable de transiciones situacionales. Los automóviles actúan en este entorno especifico como gogles fenomenológicos de captación espacial. Son nuestros mediadores preceptúales, y no solo nuestro medio de transporte. Pero porque también son nuestro medio de transporte, es que ahora nuestra percepción del espacio urbano se da, en promedio, a 1.20 mts de altura de piso a vista, con un rango de visión de cero a setenta grados y a 60 km/hr.

Ahora todo lo que se diseñe como parte de la percepción del espacio de la ciudad se da a partir de estos nuevos agentes de percepción espacial, en vías cada vez mas lastimadas, en tráficos mas saturados, y hoy por hoy en economías cada vez mas críticas. Desde el 2000, la economía de Tijuana ha ido en declive, y esto es en la ciudad que solía tener el desarrollo económico más importante en America Latina. El condado de San Diego presume en ser la ciudad mas prospera de California, lo que la convertiría en la ciudad mas rica del estado mas rico del país mas rico del mundo, eso claramente debe poner tu vida en perspectiva.

La segunda Guerra con Irak dió un gran golpe a la economía transfronteriza de Tijuana. Es por lo que hoy de los grandes espectaculares (anuncios comerciales), que sobrepoblan las calles de la ciudad, alrededor del 50% están abandonados (3) (salvo en épocas de elecciones políticas), y anuncian solo los teléfonos para conseguir información para rentarlos, o bien, recuperados por los taggers (grafitteros), hasta las siguientes elecciones, reafirmando la premisa de Torolab que Tijuana es el lugar donde lo efímero se convierte en permanente. Pero esta esencia efímera que termina por ser parte de la historia viva de este lugar de paso imaginario (porque todos terminamos quedándonos), termina por tener una presencia monumental en estas estructuras de espectaculares vacíos y de llenos, con anuncios de empresas transnacionales, de lenguajes globales, de mezclas idiomáticas e imágenes interrumpidas por los cables de luz, televisión y teléfono, que entretejen la maraña visual que da vida como sangre a un organismo urbano, y que los pájaros prefieren como lugar de descanso en vez de las ramas de los escasos árboles de las casi extintas arreas verdes en este gran desplante de asfalto y concreto.

He escuchado varias veces que las nubes de anuncios de negocios, los espectaculares de calle y el enramaje de cables no dejan ver la ciudad. Yo solo les puedo contestar que esa nube es nuestra ciudad.

(1) Taken from the text "Situated Objective" by Raúl Cárdenas-Osuna and Fiamma Montezemolo, from Strategic Question/ 40 projects in 40 publications curated by Gavin Wade for Peer Publication, England 2003.
Extraído del texto "Objeto Situado" por Raúl Cárdenas-Osuna y Fiamma Montezemolo, de Pregunta Estratégica/ 40 proyectos en 40 publicaciones, curado por Gavin Wade para la publicación Peer del Reino Unido, 2003
(2) According to the Committee of Tourism and Conventions of Tijuana, February 2003.
Deacuerdo al Comité de Turismo y Convenciones de Tijuana, Febrero 2003.
(3) This statistic is taken from an investigation made by Torolab, because there is no regulation by the Municipal Government of Tijuana for billboard use and control. They only have records of permits, not contents or maintenance, 2002.
Estadística tomada de una investigación realizada por Torolab, ya que no está regulado por el Gobierno Municipal de Tijuana con respecto a uso y cantidad de anuncios espectaculares, sólo registran permisos, no su contenido ó mantenimiento, 2002.

In spite of it all >>>> The cars keep moving. Movement takes place, so much movement that this city receives the most visitors—6,547,517 per year (2)—across the world's largest border. What doesn't get mentioned is that many (if not most) of the "visitors" are residents of this transborder region who travel to work and then return home, crossing and recrossing the border.

For people living on the Mexican side of the border, the car is not an equalizer but a regulator of life in this environment. There is no functional public transit system like the one in San Diego (although even that system isn't the best, because of its high cost), and decisions about urban design and transit are based on the private automobile. So the streets stop being for pedestrians. They lose their historic role as civic space, a place where people meet. These encounters still take place but within the flow of larger movement and at greater speed.

Perceptual relations of movement and velocity >>>> Cars will be social integrators and disassociators within this environment of urban supremacy. They will also acquire a new role as agents of spatial perception.

The city is a never-ending process of situations in transition. In this environment, cars act as phenomenological goggles through which we perceive space. They are our perceptual intermediators, not just our means of transportation. But because they are also transportation, our perception of urban space as a whole takes place at a height of 1.2 meters, with a range of vision of zero to seventy degrees, at 60 kilometers per hour.

Now everything that is designed as part of the city's perceptive space arises from these new agents of spatial perception, along roads that are more and more damaged, in increasingly clogged traffic, and in economies that are in a more and more critical state. Since 2000, Tijuana's economy has been in decline—this in the city that used to have the highest rate of economic growth in Latin America. San Diego County boasts of being the most prosperous in California, which is in turn the richest state in the richest country in the world. This clearly puts your life in perspective.

The second war with Iraq dealt a hard blow to the transborder economy of Tijuana. This is why, of the huge spectacles known as billboards that overpopulate the city's streets, about half have been abandoned (3) (except during political campaigns) and display only a phone number for rental information, or else have been appropriated by taggers (graffiti writers), reaffirming Torolab's premise that Tijuana is a place where the ephemeral becomes permanent. But this ephemerality, which ends up being part of the living history of this place of imaginary passage (because we all end up staying here), ends up having a monumental presence in these structures: spectacular vacant and occupied billboards with advertisements for transnational corporations; global languages and idiomatic mixtures; images interrupted by the electricity, television, and telephone cables interweaving the visual tangle that gives blood to this urban organism—cables where birds rest in preference to the limbs of trees, scarce now in the almost extinct green spaces of this great asphalt and concrete sprawl.

I've heard it said several times that the cloud of business advertisements, billboards, and tangle of cables won't let you see the city. I can only respond that this cloud is our city.

Torolab

POINTS OF INTEREST
ON THE WEST COAST
OF THE CONTINENTAL
UNITED STATES

FROM THE CENTER FOR LAND USE INTERPRETATION DATABASE

In its longitudinal march toward the Pacific, the identity of the American West flares and disintegrates into the sea along the thin line of its watery coast. Here, literally and figuratively, the national fabric dissolves, revealing its underlying structures.

The physical limit of the country that the West Coast represents is transcended by the technological extensions of America's reach, through communications and surveillance, through transportation by sea, and in air and space. The coast, then, is a place where the American platform changes from one medium to another, from road to ship, wire to radiowave, earth station to satellite, hardware to data.

The coast is a land of give and take, arrival and departure, consumption and excretion. Along its edge, pipelines and cables carrying stored energy and data streams rise out of the ocean and flow into the economy, while the warmed and spent discharges from outfall pipes and power plants swirl and dissipate beyond the replenished beaches.

The coast is also a front, where the military gaze is fixed out to sea, scanning the horizon for threats. Rockets launched from the coast deliver "space-based assets" that extend our vision and test the missile systems of our potential defense.

Meanwhile, like a terrestrial pulse, incessant waves take cumulative bites out of the shore. Against these perpetual conveyors of disintegration stand the individual, municipal, and federal structures built to deflect and defend, and to preserve the continent's littoral heritage.

MATTHEW COOLIDGE
Director, Center for Land Use Interpretation

Matthew Coolidge is founder and director of the Center for Land Use Interpretation, a nonprofit organization based in Culver City, California. CLUI employs a multimedia and multidisciplinary approach to disseminate knowledge about how the world's lands are apportioned, utilized, and perceived, and produces exhibitions in collaboration with museums and galleries.

CHERRY POINT REFINERY, NEAR FERNDALE, WASHINGTON

The BP Cherry Point Refinery, north of Ferndale, Washington, processes over two hundred thousand barrels of oil per day, making it the third largest refinery on the West Coast. The four major refineries on the coast around Seattle provide the Northwest with its gasoline, diesel, and jet fuel. Similarly, San Francisco and Los Angeles both have five major refineries in their environs. The Northwest Coast refineries are supplied mostly by oil delivered by ship from northern Alaska oil fields. (California refineries use Alaska and California crude. California is a major oil-producing state, and portions of the coast literally drip oil, as can be seen at the oil seeps on the coastal cliffs near Santa Barbara, where the only offshore oil rigs in the country outside of the Gulf of Mexico are located.) Cherry Point produces gas sold at ARCO stations and AM/PM minimarts in the West.

LOOKING EAST ALONG THE FORTY-NINTH PARALLEL AT POINT ROBERTS, WASHINGTON. THE HOMES ON THE LEFT ARE IN CANADA, AND THE ROAD IS IN THE UNITED STATES. THE LARGE ORANGE-FLAGGED TOWER MARKS THE BORDER CHECKPOINT.

int Roberts is a coastal, geographic oddity. It is a five-square-mile piece of the itish Columbia mainland that hangs below the international border, set at forty-e degrees of latitude, creating a community of around one thousand U.S. resi-nts cut off from the rest of the lower forty-eight states. It is a twenty-five-mile ve through Canada to get to the rest of Washington State, and many Point berts residents work in Canada. From the time the borderline was established, in middle of the nineteenth century, until the early 1900s, Point Roberts was a mil-ry base. Later, due to its favorable weather, it became a community of summer mes for Vancouver residents, and eventually grew into a year-round community. w it is a popular place for Vancouverites to pick up packages shipped from the ited States, avoiding the hassle and expense of Canadian customs.

INTALCO SMELTER, NEAR FERNDALE, WASHINGTON

The aluminum smelter on the coast near Ferndale is the nation's largest aluminum smelter and the Northwest's largest single consumer of electricity. The Intalco smelter covers three hundred acres and employs more than one thousand people. During the California energy crisis of 2000–1, the facility was paid not to operate so that the energy it normally consumed could be sold to California. Washington State has several large aluminum plants, enabled by the large amounts of electricity available from dams along the Columbia River and the historically high demand for the material by Boeing, which has manufactured most of its aircraft in Washington State since the end of World War II. Alumina, the material from which aluminum is smelted, arrives by ship from Australia and is off-loaded at the company's dock next to the plant.

WEST POINT TREATMENT PLANT, SEATTLE, WASHINGTON

The West Point Treatment Plant is the largest water treatment plant in [the] Northwest, processing around 125 million gallons of Seattle's sewage per day. B[uilt] in 1966 on the edge of Fort Lawton, the plant was upgraded in 1991 and 19[] at a cost of over $500 million. Treated water is ejected into Puget Sound vi[a a] three-quarter-mile-long outfall pipe. Each of the major cities on the West Coas[t—] San Diego, Los Angeles, San Francisco, and Seattle—has one primary sewage pl[ant] with smaller ones serving the surrounding communities.

LUMMI FLATS, WASHINGTON

The remnants of a U.S. Navy communications site, part of Marietta Navy Base, remain on the coast at Lummi Flats, a tidal estuary near Bellingham, Washington. The base had closed by the 1970s, and much of the property was taken over by the Lummi Nation. Beyond the flats, a four-mile-long dike forms a pool where the Lummi raise salmon, oysters, and clams in an aquaculture operation.

PORT OF SEATTLE, WASHINGTON

By some measurements, Seattle's port is the fourth largest in the United States. [] six working piers owned by the port handle mostly containerized cargo, u[sing] cranes that are fourteen stories tall. A few major shipping companies dominate[the] trade in Seattle, including APL, which was treated to a totally remodeled Termin[al] recently, and Cosco (China Ocean Shipping Company). Cargo bound for Asia f[rom] the Northeast often travels via container on rail cars to Seattle, a day closer by w[ater] to Asian markets than Los Angeles/Long Beach (which manage twice the volum[e of] the ports of Seattle/Tacoma). In fact, Seattle handles more of New York's A[sian] cargo than New York.

PUGET SOUND NAVAL SHIPYARD, BREMERTON, WASHINGTON

...get Sound Naval Shipyard was founded in 1891 and is now the largest active ...ipyard on the West Coast. This densely built industrial area next to the town of ...emerton employs nearly fifteen thousand people. Though ships are rarely built ...re now, it is one of the navy's busiest repair yards, engaged in updating and ...novating submarines, battleships, and aircraft carriers. It is a major decommis-...ning site for ships and submarines and has a mothball fleet of more than twenty ...ssels. It is also home port to several active navy vessels, including aircraft carriers ...the Nimitz class, the world's largest warship, powered by two nuclear reactors ...d manned by a crew of about six thousand.

NAVAL SUBMARINE BASE, BANGOR, WASHINGTON

The Bangor submarine base manages the third largest collection of nuclear weapons in the country, with approximately 1,700 Trident missiles stored either at its hilltop depot or on board its fleet of eight Trident submarines, which still roam the seas on secret missions. The base covers more than seven thousand acres on the shores of Hood Canal, in Puget Sound. Established as a munitions depot during World War II, it was activated as a sub base in 1977. Base closures elsewhere have led to recent growth at Bangor, and now more than ten thousand people work at the base. Puget Sound and San Diego are the most militarized areas on the West Coast, now that the military bases in the San Francisco Bay Area have been closed. The largest weapons depot on the coast, however, is in densely developed Orange County, California.

VIEWING PLATFORM, CAPE FLATTERY, WASHINGTON, WITH TATOOSH ISLAND BEYOND

The westernmost and northwesternmost point of land in the lower forty-eight states is Cape Flattery, off the Olympic Peninsula in Washington State. This land is owned by the Makah, an Indian tribe in the headlines a few years ago for resuming traditional whale hunting. The point is accessible by a dirt road and then a path, which leads to a rustic natural overlook platform. The interpretive site built for visitors describes the history of the Makah but makes no reference to the location's geographically superlative quality.

At the Bandon Cable Station, on a remote stretch of the Oregon coast, south Coos Bay, the China–U.S. Cable Network line and Transpacific Cable No emerge from the sea and connect to the continental data grid. The China–U Cable, which went online in 2001, has a capacity of eighty gigabytes of data second and makes a nineteen-thousand-mile loop, touching at Japan, Guam, So Korea, Taiwan, and two points in China. Transpacific Cable No. 5 connects Jap and the United States, via Hawaii and Guam, and went online in 1996. There currently fewer than ten major submerged fiber optic cables spanning the Pac Ocean that make landfall on the West Coast. They carry nearly all the Inter traffic to and from Asia.

LEWIS AND CLARK INTERPRETIVE CENTER, CAPE DISAPPOINTMENT, WASHINGTON

In November 1805, Lewis and Clark reached the furthest westward point of their journey at Cape Disappointment, at the southwestern corner of Washington State where the Columbia River meets the ocean. Today, the Lewis and Clark Interpretive Center sits atop a former coastal battery that was part of a network of fortifications protecting the mouth of the Columbia River—the West Coast's Mississippi. Most of the hundreds of defensive structures along the coast were built during World War II and afterward to defend the coast's strategic places against enemy ships and airplanes. Major cities and harbors were encircled by watchtowers and gun emplacements, some of which have been converted into museums, such as the Nike missile battery in the Marin Headlands north of San Francisco and Fort MacArthur, which once defended Los Angeles Harbor. Many more are overgrown, forgotten, and crumbling into the ocean. By the mid-1970s they were no match for the enemy's intercontinental missiles, which, if launched from Siberia, would arrive at their West Coast targets in minutes.

RUINS AND ANTENNAS AT THE EDGE, BEYOND THE LIGHTHOUSE AT CAPE BLANCO, OREGON

The second most westerly point on the West Coast is Cape Blanco, Oregon. T cape was used as a landmark by Japanese submarines during World War II in t attempts to set the forests of the Pacific Northwest on fire. On the first of th raids, a small pontoon bomber was launched from the deck of a submarine flown south from the Cape Blanco lighthouse to the forest near Brookings, Oreg where it dropped an incendiary bomb. Though a small fire was started, the moist of the forest kept it from spreading quickly, and the fire was easily extinguished

On the West Coast, the longest stretch of coastline without a coastal road is the Lost Coast, fifty-five miles of Northern California from northwestern Mendocino County to near Ferndale in Humboldt County. The remote development of Shelter Cove, a recreational subdivision started in 1965, is located at the terminus of the road that connects directly to the inland highway, piercing the middle of the Lost Coast. Shelter Cove is the only community on the Lost Coast, a rugged and uninhabited anomaly in a state where Highway 1 and 101 provide a nearly continuous view of the entire coast. The existence of these highways provides access, changes development patterns, generates tourism, and alters the physical form of the coastline as well.

RADIO ANTENNAS, POINT REYES NATIONAL SEASHORE, CALIFORNIA

Until recently, Point Reyes was the largest and most important commercial ship-to-shore communications site on the West Coast. Hundreds of radio antenna towers were spread out in several clusters on the peninsula, until AT&T and MCI closed their adjacent communications stations here in the late 1990s and the National Park Service began to remove the antennas. By focusing the radio waves with multiple antennas and bouncing them off the ionosphere, these stations had coverage throughout the Pacific. The Italian Guglielmo Marconi set up the first successful transpacific broadcasting station here in 1913–4. (On the East Coast, Marconi set up a similar, transatlantic broadcasting station on Cape Cod in Massachusetts.) After World War I, the U.S. government seized all of the vital national assets from the British-owned Marconi Company and formed the consortium RCA, composed of AT&T, General Electric, and Westinghouse, to run them. Though the Coast Guard continues to operate communication facilities at Point Reyes, the last commercial message was transmitted from this site in 1997— up to the end, in Morse code.

CRESCENT CITY HARBOR, WITH WAVE ENERGY DISSIPATION STRUCTURE ON DISPLAY, CALIFORNIA

...ch of downtown Crescent City, California, was destroyed in March 1964 by a ...nami caused by an earthquake in Alaska. The damaged area of downtown has ...ce been turned into an open shoreline park, and the shore has been fortified with ...rap, berms, and large, faceted concrete wave energy dissipation structures called ...rapods. About twenty large earthquake-generated waves have hit the West Coast ...the past two centuries, but only two, one in 1817 and the one in 1964, had ...ficient energy to do major damage. Many low-lying communities on the ...rthwest Coast have tsunami alert sirens and posted evacuation routes.

For much of the twenty-seven miles of Malibu's coast, a single row of homes a
the Pacific Coast Highway creates a wall between the public road and the b
which state law says is public below the point of highest tide. The wall of home
effectively blocked access to the beach, creating a secure, private recreational
for the celebrities who live—or at least have homes—here. Pressure is mounti
force through passages for the public, and attention is currently centere
entertainment executive David Geffen's home. A public access gate he agre
build twenty years ago when he expanded his property remains locked while
battles continue.

MARINELAND OF THE PACIFIC, PALOS VERDES PENINSULA, CALIFORNIA

Marineland was a major "Sea World" type attraction until it was bought by
owners of Sea World in 1986 and shut down. Marineland's performing killer w
Corky, who was originally captured in 1968 near Pender Harbour, B
Columbia, was one of two animals that were moved to Sea World in San Diego
renamed Shamu. Much of the original Marineland structures have been
down, and the site, on the Palos Verdes Peninsula, south of Los Angeles,
be redeveloped eventually. In the meantime, it is a popular Hollywood fil
location. Films requiring coastal scenes with fiery explosions, such as *Ch*
Angels, *Conair*, and *Face/Off*, seem to favor this location.

POINT MUGU, CALIFORNIA

No site on the West Coast extends its reach beyond the coast in quite the same way
as Point Mugu. The Naval Air Weapons Station in Ventura County, north of Los
Angeles, launches missiles past tracking stations in Hawaii and as far as the Indian
Ocean, as part of vast restricted airspaces called the Pacific Missile Test Range and
the Naval Western Range Complex. Sometimes shots from here go inland, to
impact areas at China Lake, California; Tonopah, Nevada; and White Sands,
New Mexico.

SAN ONOFRE NUCLEAR GENERATING STATION, near SAN CLEMENTE, CALIFORNIA

The San Onofre Nuclear Generating Station (SONGS), between Los Angeles and San Diego, is one of two nuclear power plants directly on the coast. Unlike the Diablo Canyon nuclear power plant, which is on a private road on a restricted stretch of coastline north of Morro Bay, California, San Onofre is on a narrow strip of land between Interstate 5 and a popular surfing beach. The plant generates around 20 percent of Southern California's energy.

MEXICO-U.S. BORDER

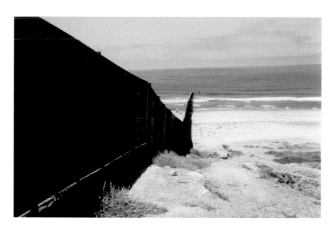

About half of the border between Mexico and the United States is a river, the Rio Grande. The other half, from New Mexico west to California, is mostly barbed wire cattle fence. At a few places, the border fence becomes more imposing, such as at its final stretch along the border at Tijuana, where it travels through bare, hilly terrain, heavily transformed and monitored by the U.S. Border Patrol, then finally plunges into the sea. The metal sheets, around fifteen feet high, that comprise the fence here are military surplus runway landing mats from the Vietnam War era.

SEA LAUNCH, LONG BEACH, CALIFORNIA

A converted oil-drilling platform—homeported at Long Beach Harbor, at the tip of a long finger of artificial land that was once part of the naval shipyard—Sea Launch is the only dedicated civilian satellite launch site on the West Coast. Satellites are delivered to this facility and loaded onto a special ship which, along with the launch platform, travels thousands of miles south to an equatorial launch site in the Pacific Ocean. This unusual but operational system is a joint project of Boeing, working with Russian, Ukrainian, and Norwegian companies. Since the first test launch in 1999, several communication satellites have been sent into orbit from this mobile, itinerant part of the West Coast.

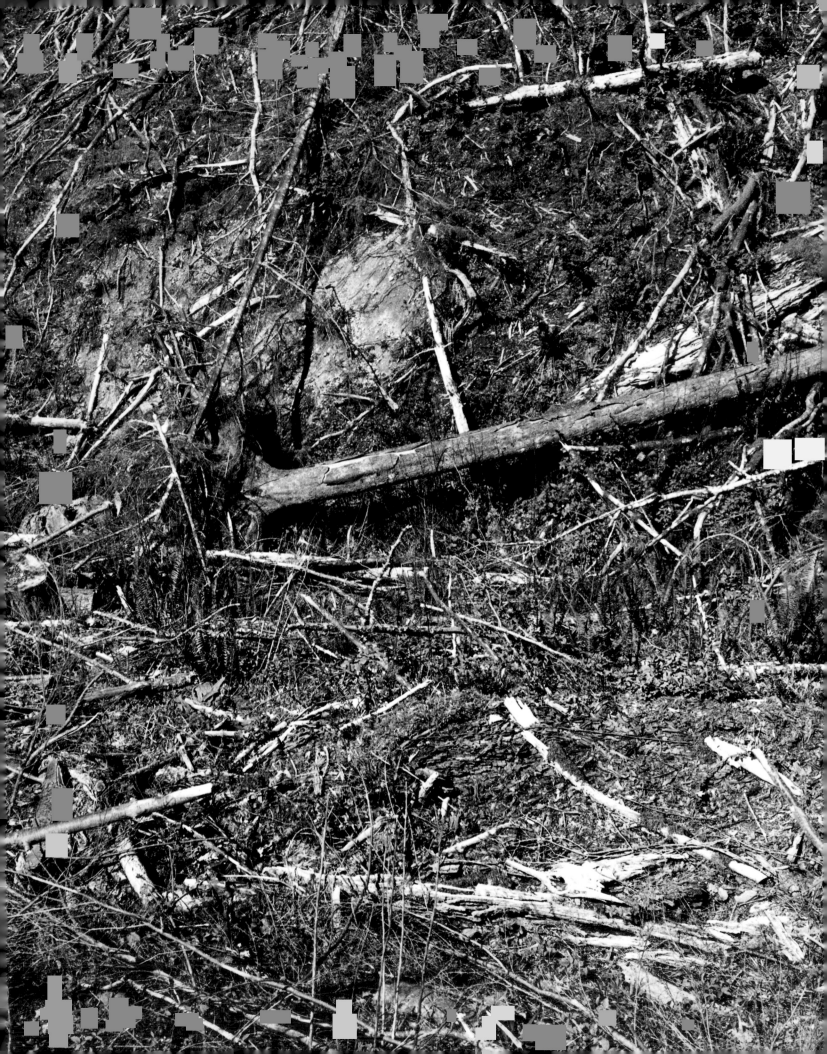

Matthew Stadler

THE REGIME OF THE PICTURESQUE

What kind of landscape is this, home to what manner of things? Why do poor people die in marshes preserved for birds? What is "nature" when designed by planners and preserved by law? What is a "world campus," or, also nearby, an "industrial park?" The language itself is distressed, made to bridge vast distances connecting disparate things. The very ideas of "city" and "country" seem misshapen when laid over this terrain. The problem is art historical as

In Portland I take my three-year-old on the commuter train past the Nike World Campus to an intersection of two highways. The train stops, and a path leads into the Tualatin Hills Nature Park—old second-growth woods, marshlands, a small field by the highway. Herons nest here; migratory birds use it in great numbers. My kid and I wander the woods, imagining solitude. The sleek train glides by, but we can't see it through the screen of trees. A week after our visit, the police find human remains, a skeleton, in the marsh. The nature park is "saturated with transient camps," apparently the result of the commuter train and a chronic shortage of shelters downtown. While young Nike executives ride out to their wooded campus every morning and back to urban lofts at night, the homeless have been on a reverse commute.

much as it is political. Ideas such as "nature," "country," and "city" arrived here not long ago as part of a conceptual apparatus transmitted largely through the medium of European landscape painting (a practice that itself developed in concert with Europe's long evolution from feudalism into capitalism). How could such nuanced ideas fail so miserably when laid over an essentially familiar terrain?

Their poor fit is general. Throughout the West of North America the late arrival of the European project triggered patterns of city building that both aspired to European ideals and lacked Europe's particular history. In many cases, this gave birth to fabulous, theatrical grotesqueries—drag queen cities preening before their loyal audiences. Further, it has motivated a widespread preoccupation with untenable ideals such as "native" and "natural," essentially spiritual notions whose power can be traced directly to what I will call "the regime of the picturesque." On such a stage, the European project has here played out its particular script. *Baja to Vancouver* is an artifact of that process.

Left:
Robert Adams
Clearcut, Humbug Mountain, Clatsop County, Oregon, 2001
Silver gelatin photographic print
Approx. 11" x 9"
Courtesy Fraenkel Gallery, San Francisco
© Robert Adams

Nature and city and countryside were recent dramas when they arrived in the North American West in the late eighteenth and early nineteenth centuries. Their vitality and meanings had first emerged less than two hundred years earlier, as Europe's feudal economies withdrew and trade, directed through cities, became the central engine of prosperity. During this period, which Marx called "early Capitalism," those social relations, technologies, and ideologies that accelerated the swift transfer of goods and capital prospered. New ideas, such as the division and hierarchy between city and country or the existence of a kind of virginal terrain called "nature," became robust and commonplace, while older notions that impeded trade became quaint or were forgotten.

The authority of these ideas—"city," "country," and "nature"—was deeply dependent on the European ideology of landscape, or "the regime of the picturesque." This regime is best understood as a formula for seeing—a normative order and set of meanings the educated eye imposes on a terrain. During Europe's broad shift into a wage-based trade economy (first of agriculture and, later, manufacturing), a newly mobile, moneyed class dealt with its anxiety about these changes, in part, by reimagining the whole drama through the medium of landscape representation. Their highly refined imagery of Edenic, preindustrial country life became a kind of gilding for the brutal realities of wage-labor, mechanization, and the eighteenth-century consolidation of land owner-ship under Britain's proliferating enclosure laws. (This analysis is based on the work of John Barrell and Raymond Williams, among others.)

The Picturesque, as theorized at the time by William Gilpin, was just one iteration of this larger artistic practice. Others included rustic painting, neoclassical landscape painting (in the style of Claude Lorrain), and, later, Romantic painting. They share a common ideological function—conflating imperiled landscapes or sites of past economic violence (typically wilderness or rural lands) with the spiritually redemptive presence of beauty, sublimity, or the picturesque. (I'd like to wrest this last word away from its historically narrow use and make it into a lower-case umbrella for all these iterations.)

The West Coast had heretofore been innocent of these particular dramas. When Euro-American migration began in earnest, in the early nineteenth century, there was no agrarian past here (or none that survived the apocalypse of Europe's arrival), no evolution from feudalism into a market-based economy, no exodus of the poor from closed-off common lands into the cities, no pastoral tradition, no notion of the picturesque, nor any Romantic sensibility to invent the "country" as a kind of lost Eden to which one could escape, through art, from life in hellish cities.

There were no cities. The Tualatin Hills Nature Park and Nike World Campus, circa 1830, were marshlands, bordering on heavy stands of Douglas fir, populated by beavers and a nomadic hunting and gathering tribe called the Atfa'lati. The Atfa'lati calendar named the "months" by saying where and how each would be spent: here a camas root field to be reaped in late spring; there a lake by which to harvest sagittaria root in midsummer; elsewhere, lowland encampments for sheltering in winter.

To Euro-American travelers, these encampments might have looked like small cities. Many were as cosmopolitan and densely populated as Europe's. Long houses sat scattered amidst paths, usually beside riverbanks; in each, dozens lived, with and without family relation; strangers passed through amicably, able to trade in a common language and with a transferable currency (dentalium shells, called *Haiqua*). There was an

especially big and busy cluster of a dozen encampments through a stretch of the Columbia River along what is now called Sauvies Island. Atfa'lati walked a few days over mountains to trade here with Chinook of the lower Columbia, Klikitat from the north, Shahala from the steep-sided gorge upriver, and others. Fur traders, explorers, and enterprising whites passed through and did business here too. Rick Rubin, in his exhaustive study of the Chinook, *Naked Against the Rain*, calls this island, circa 1780, "perhaps the most thickly settled land in all of America north of Mexico."[1]

But was this a city? The Atfa'lati calendar provides a window on the conceptual strangeness of such European notions. Encampments, like the rest of the terrain over which indigenous tribes moved, were not geographical so much as they were temporal—they marked one part of a cyclical sequence through time, rather than embodying qualities of place. *Here is summer*. Everything about the European city—its self-regard, its notions of native versus stranger, its weird fiction of permanence rooted only in the stability of an administrative apparatus that has conflated itself with a piece of land—was insensible to the coast's indigenous cultures. City building, when the European project arrived on the Pacific Coast, would transpire on a terrain that had been thoroughly innocent of it.

The general banality of early West Coast landscape painting—its imitativeness and parroting of generic form—should not surprise us. Painters here had no society, only the picturesque conventions they had brought with them. Lacking cities, they painted dispatches from Eden. The problem wasn't broadly American; during these same middle decades of the nineteenth century, the painters of the Hudson River school, including Sanford Gifford, Thomas Cole, and Frederic Church, pioneered

what came to be known as American luminism. The advantages that helped catalyze their innovations expose, by contrast, the unique shape taken by the regime of the picturesque out West.

American luminism was concentrated in New York's Hudson River Valley, a terrain where two hundred years of Euro-American settlement had laid the base for both an agrarian countryside and growing financial and manufacturing centers (New York City being the largest and most important). Like their English predecessors, the school's leading figures were predominantly of a class that could move between city and country, occupying comfortable positions of ownership and leisure in both places. Thomas Cole's social advantages, for example, or Sanford Gifford's decades of travel throughout Europe and the Middle East, were aspects of a gentleman's life that posed a fair analogue to the circumstances from which most European artists grew. Embedded in a robust dialogue of city and country, deeply informed by contemporary European discussions, the society these men enjoyed helped to shape the landscapes they painted.

By contrast, the West Coast was home to only a narrow part of this social and economic web. The owning classes never really made the trip, except as tourists. Well into the late nineteenth century, Euro-American settlement brought an ocean of working men and industry to this terrain, and very little else. In Seattle, women were, famously, imported by boat in the 1860s, like missing, essential machine parts. Families began making the trip to Oregon much earlier (in the 1840s—the difference can still be felt in the social cast of its small cities), but the cultural matrix of city and country was almost universally absent until the second half of the nineteenth century. Without any nuanced dialogue between these two ideals, the pressures that informed and gave meaning to landscape representation did not

exist here. Painters lacked context, audience, colleagues, and patrons. Terrain was engaged so ferociously by industry, with its avalanche of workingmen, that it could hardly be enlisted in the pictorial dialogue of landscape painting with any subtlety or meaning.

At the same time, this unbridled expression of industry brought huge pressure to bear on the regime of the picturesque. Its mollifying powers were sorely needed, even as the absence of a social web (extending across classes to link city and countryside) crippled the engine that had usually powered its meanings. Severed from any meaningful discourse of high art, beauty and sublimity were conjured willy-nilly across the whole terrain, wherever circumstances coalesced to provide an occasion for such meanings—a grove of cedar cut to make an afternoon's arcadian parterre; a log Parthenon erected as part of a trade fair lasting nine months; vistas hewn from thick woods to serve the clients of tram companies running tracks into surrounding wilderness for a season. These theatrical spaces were as brilliant and evanescent as the annual fireworks and flag waving that made up the bulk of America's cultural claim on these new territories. Painters painted scenes, yes; but their work was imitative and cursory, puny beside the real vigor of the unbridled picturesque now spilling across an undefined terrain.

Settlers inscribed the first European geometries on Atfa'lati terrain in the late 1840s, about the time the U.S. government came into possession of these lands and offered them free to Euro-American settlers who promised to make them "productive" by harvesting trees, extracting minerals, or cultivating and farming crops. Rows were plowed, foundations set. Houses went up to host permanent settlement.

By this time smallpox and malaria had decimated the Atfa'lati, reducing their numbers from an estimated five thousand in 1790 to fewer than one hundred in the 1840s. By 1855 the terrain once called cha-kepi was comprehensively mapped and divided by the U.S. government. Sixty-five remaining Atfa'lati were moved to a shared reservation seventy miles southwest, nearer to the coast. Within a generation all Atfa'lati had intermixed and within two the last living speaker of the language, Louis Kenoyer, died without having taught it to anyone.

The new settlers of the Tualatin Plain proceeded as if on a strangely empty stage. They saw little or no history, just raw material—a kind of vast, open-air factory to be set up and run. This anchorless, infinite potential had the curious double-effect of inviting the most immoderate ambitions while also providing little or no cultural authority with which to carry them out. The task of civilizing the land, bringing it to full fruition within a visible grid of ownership, had to be carried out by fiat. What came to be called "cities" were simply those places cleared or flattened early enough to become drains through which remaining resources could pour onto ships and trains bound for distant ports. Only a massive deployment of the regime of the picturesque has kept us from leaving the frank brutality of this essentially industrial project naked and unadorned.

This regime has produced its deepest meanings where artists trained their attention on city building rather than on "nature." In part, this is because city building, in the West, is home to the regime's most robust expressions— merely to record its progress is to engage the picturesque in all of its double-valence. By "double-valence" I mean the capacity of the picturesque to at once register the brutality of things and attempt their appeasement through art. J. M. W. Turner provides a masterful example with his 1840 painting, *Slave Ship (Slavers Throwing Overboard the Dead and Dying, Typhon Coming On)*. Faced with this image, one has to suspect Turner of a deep political

sophistication. The coming storm is glorious. Twin masts from the distant ship, sailless, penetrate the light. In tiny strokes, barely visible in the foreground, a handful of helpless men thrash and drown. The painting depicts a widely reported incident from 1783 when the captain of a slaving ship, the *Zong*, threw his cargo of slaves overboard so that he could collect on an insurance policy for losses at sea. Turner has infused the scene with every seduction of his mature style: color saturation; minimal figurative work; an implied horizon floating in an overall field of light; the masts' sharp disruption of this field. He diminishes the horror of this history to a few agonizing strokes at the bottom and at the same time underlines it with the painting's title. In effect, Turner exposes the underlying program of Romantic landscape representation—refiguring sites of loss as occasions for ennobling apprehension of the sublime—by carrying it out in full view.

On the West Coast this kind of double-valence pervaded the challenge of city building. One finds it in such mundane scenes as an early pear orchard bordered by dense curtains of old growth, cows grazing amidst massive stumps on the platted mud field of downtown Portland, or the course of a highway blasted through a mountain pass. On the West Coast there was no "nature," properly speaking. That traditional site of the sublime required a city and a countryside from which a certain kind of traveler journeyed before, finally, reaching it. Euro-Americans arrived and found only terrain—vast and undifferentiated—which they treated as an economic storehouse. "Nature" here was an artistic projection onto what was in essence a vast open-air factory floor. Where artists turned their energy away from such projections and toward cities and infrastructure, the regime of the picturesque achieved its most potent double-valence.

The photographs of Carleton Watkins (1829–1916) are among the most striking of these early breakthroughs.

Watkins, who came from New York to California as a young man, turned an unsentimental eye on both terrain and industry, often within the same frame. His compositions are evenhanded; there is no drama of purity or violation. A hand-built mill straddles a vigorous freshet in a gorge that is marked by logging. No part of the scene announces its virtue or corruption. The gorge simply extends toward a vanishing point, marked by a long line of railroad tracks, laid on ties logged and milled here. Watkins recorded indigenous settlement in the same way. The tragedy in these photos is largely retrospective: the small numbers of Indians; their children looking sick or poorly fed; the presence, nearly always, of distracted whites setting up camp nearby.

Watkins's photographs suspend the worst impacts of the European project inside a diffuse, almost indifferent sort of formalism. They neither obscure nor condemn them. In painting of the time this effect was rare: America had no Turner. The Hudson River school painter Albert Bierstadt, who traveled with Watkins and sketched many of the same scenes (to bring back to his massive Hudson Valley mansion where he rendered them on huge canvases), was incapable of such a frank regard. His dramatically rendered Western paintings are either divorced from the region's brutal particulars—the decimation of indigenous tribes by disease, the forced dispossession of those remaining, the industrial extraction of timber and minerals, etc.—or they engage them through an allegorical impulse so deep the events themselves become generic symbols, stripped of any specificity. There can be no dialogue between horror and its appeasement when the latter has completely erased the former.

Where Watkins relied on a kind of formalized distance to calibrate the double-valence of the picturesque, recent photography has often pursued the same effect

through more pitched or heated juxtapositions. Stan Douglas's urban portrait, *Every Building on 100 West Hastings*, 2001, summons these kinds of charged pairings in the empty pools of streetlight fronting this downtown Vancouver block's shadowed facades. West Hastings (in Douglas's print poised like an aging starlet in the moment before her rediscovery by Hollywood) was home to a multitude of transients, among them scores of prostitutes who were picked up and taken to Piggy's Palace, a biker's club at a disused pig farm on the outskirts of Vancouver. In that hybrid landscape of lost farms, new housing, and brightly lit highway malls, nearly sixty of these women were killed and buried. Their lives haunt the streetscape Douglas has sealed in the amber of Hollywood's cinematic conventions. Douglas's print summons cinema with such ease, its complicity in the alienating, essentially brutal economy he depicts comes as a kind of afterthought, an aura of glamour that is as repulsive as it is seductive. The aura isn't part of the discourse so much as it is a kind of glow around it, generated by the complete evacuation of depth, so that the stage-flat facades are made to hoard the entire sweep of this block's history in the surface of the film. Emptied of its population, the street has also served as the backdrop for any number of American movies filmed in Vancouver (to take advantage of lower labor costs and exchange rates). Captured this way, the image of West Hastings Street circles the globe for the pleasure consumers of commercial cinema. Douglas's print collapses these two economies into a third, historical one: the frank meat-rack of itinerant labor that first brought life to this street. *Every Building on 100 West Hastings* conflates these histories in the poised present of the photograph.

This kind of rush to the surface is general throughout West Coast art practice. History has only barely begun here, the new European history, and its traces are indeed thin as film. It should not surprise us to find artists constructing analogous surfaces on which history's illusionary depth can resolve into an infinitely thin repose.

This motion is the locus of meaning in Seattle photographer Glenn Rudolph's massive prints. Whatever else one sees in them—the flimsiness of settlement here, fantasy-besotted settlers enacting their made-up lives, the picturesque landscapes—one sees the vortex of the shutter drawing everything toward its own depthless logic. Rudolph opens the camera's eye (typically he shoots with a bulky 8 x 10) and the whole terrain—its weather, habitation, and history, all of it—comes swarming in. Like Douglas, Rudolph organizes this scrim of information around preexisting conventions, in his case painterly rather than cinematic.

Rudolph's compositions are eerily familiar to any student of eighteenth- and nineteenth-century painting. Caspar David Friedrich haunts them, as do Turner and Albert Pinkham Ryder. Notably, the landscape of his investigation is that indeterminate third space, neither city nor country, that was home to Piggy's Palace. The freshness and peril of settlement in these places is written in the perplexity and grim assertiveness of those Rudolph has caught living here. Stranded amidst dense development they appear, nevertheless, to be completely cast out into the wild. In fact they are in neither city nor country. Rudolph's prints show the strange failure or irrelevance of these categories by documenting some of the lives that thrive in the space of their breakdown. They ring true because his subjects actually *do* live poised against a great and shallow, wrong backdrop. We have been posing for European portraits on this indifferent terrain for two hundred years now, alongside the trees and mountains and vistas of our picturesque imagination.

This broader condition comes sharply into focus in the paintings of Michael Brophy, who, unique among the

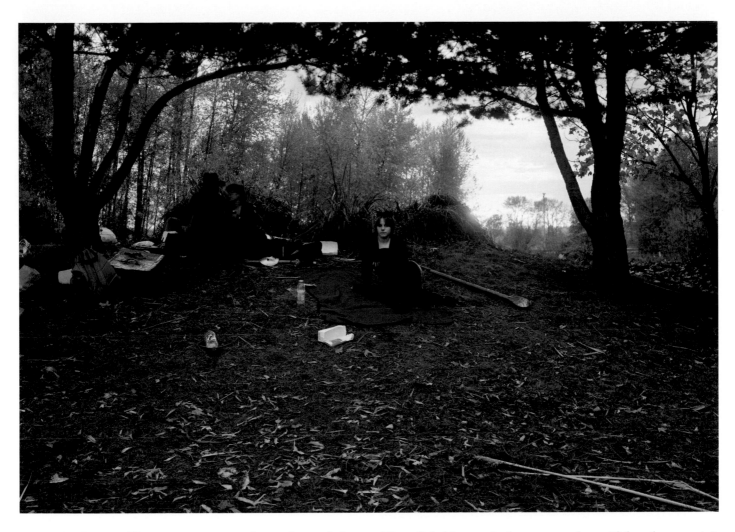

artists in *Baja to Vancouver*, engages the regime of the picturesque by bringing its original tools to bear on contemporary terrains. He paints landscapes—and what amount to Renaissance oil portraits—of slash piles, timber, trees, and the men who cut them. "The forlorn and confused stumps in a painting like *New Found Land*," essayist Charles D'Ambrosio writes in a monograph on Brophy's work, "seem to have sat … as a courtesan would, and so their facelessness is haunting. The implication is there, the hint of portraiture, the suggestion that someone is staring back at the painter."[2] The beauty of these stumps poses questions, not about logging or forest preservation, but about art and the dramas it enacts.

How did this terrain become so beautiful and so tragic? Because of the way art depicts it.

In the wake of these paintings, one sees Brophy's landscapes everywhere. The checkerboard of clear-cut and thick forest begins to look less like chaos and more like an inexorable logic. Slash spills down into swollen creeks; power lines cut across highway vistas crowded with tourists seeking the immaculate view. History takes shape in the wanting narratives these glimpses suggest. And like these momentary tableaux, Brophy's canvases project an uncanny ambivalence, poised between ease and impatience. The painter has frozen this terrain in the formalities of portraiture so that, in that still moment, we can enjoy the luxury of art and its coherence. Yet he makes a point of executing his renderings with all the speed and impatience of the machine caught in his sights. His brush dances heavily across vast stretches of the canvas, making its claims with the greedy

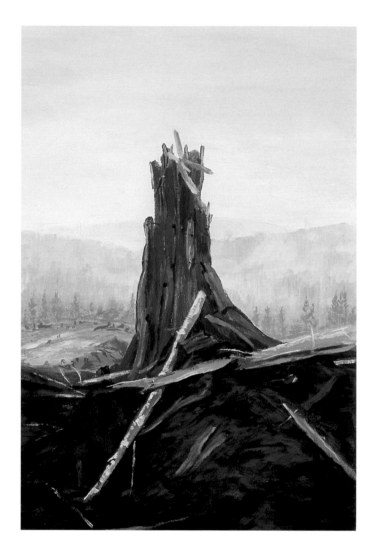

impatience of a logging show—this will be sky; this will be trees—and then it bears down like a drill. This unusual strategy is strangely analogous to the antivirtuosic power of seminal bands like Black Flag—all crash and burn within a completely appropriated formal rigor—and it puts us face to face with the beguiling ugliness of West Coast beauty, as hastily constructed by the regime of the picturesque.

Today Portland boasts a metropolitan plan that legislates the most far-reaching iteration of the regime of the picturesque of any North American city. The plan's reach is unusual, but its ambitions are, by now, familiar: while the region's farms remain predominantly industrial, land-use regulations favor small family farms in the greenbelt around the city (statewide, migrant labor is still doomed to the same pauper's grave that swallowed whole generations in England); nearby wilderness presents a thin face of sublime majesty over the ravenous industrial apparatus of harvest and extraction. Tualatin Hills Nature Park and Nike's World Campus are expressions of this same regime. The creation of such landscapes accomplishes the same ends as did eighteenth-century landscape painting—at once registering a kind of ideal that, if it ever existed, has now been lost and making the terms of that loss more palatable by shrouding it in beauty.

This is not a cynical project. People need solace, even as we drive whole populations into their graves. At the Tualatin Hills Nature Park, manager Joan Andersen-Wells tells me that hundreds of volunteer hours are needed to keep the preserve from succumbing to invasive aliens. "The blackberries, English ivy, scotch broom, they're voracious. We try to preserve the native landscape and eradicate invaders, but the work is endless." Beyond opportunistic plants, the park must also resist or deal with the intrusions of unwanted people. "We can have them arrested. The police have given us the power. A lot of these people prefer to be out here, they don't like the shelters. But we can't be a campground for transients; we're a nature park."

This is the logic of the picturesque. Where Turner painted drowned slaves at the bottom of his canvas, we maintain marshes where poor people go to die. It is difficult to look upon such a spectacle with the calm or clarity of a Carleton Watkins, and yet we need such a penetrating regard now more than ever. Robert Adams,

who shares Watkins's ability to subsume passion within a rigorous attention to form, has lately photographed the clear-cut forests of Oregon's Clatsop County (on some of the same hillsides that Brophy has recorded in paint). His prints show us the slash piles and snares of industrial logging. Rather than composing them to imply any kind of center, Adams lets the subject's twisting, broken geometry trail from corner to corner of the photograph, like some kind of industrially enacted Brice Marden painting. He does not cast these scenes in a drama of good and evil, but allows logging's violent geometry to establish dominion on the surface of the photo, suggesting a kind of catalog of all iterations of the forest. Seemingly despite his own moral revulsion to the waste of industrial logging, Adams renders its logic with the kind of astonishing double-valence we find in Robert Capa's photographs of the living and the dead in wartime; there is brutality, but there is also a sort of doomed grace and tenderness.

Adams, like Brophy and Rudolph, uncovers meaning on a landscape that can never be resolved as city or country or nature. Whether in Brophy's clear-cut vistas and crowded scenic overlooks, Rudolph's patchwork landscape of manicured tract housing and parklands beneath power lines, or in the wreckage of a forest turned factory as depicted by Adams, none of these ideals can hold. Instead, we witness a kind of mongrel space marked by all of them.

In their short essay "Last Seen," Diana George and Charles Mudede call this mongrel space "public wilderness." Public wilderness, such as that which Mudede and George find along the margins of Seattle's Highway 99, exists in the interstices between what were once called "city," "country," and "nature." It is "a produced emptiness; a manufactured nothingness that crosses both the realms of the social and the natural ... the site of a contest between different uses of emptiness."[3] This evacuated realm creates space for a population that is neither urban nor rural, nor strictly suburban, the workers and consumers of an economy based on undifferentiated terrain: illegals in cramped truck-farm housing; contract workers in townhouse rentals near the vast sheds of light industry; loggers commuting from leased condos to ever-shifting logging sites; families weathering jobless stretches in weekly-rate motels; prostitutes trapped on the pleasure strips of disused highways; the homeless riding commuter trains to marshes where they sleep and die. They wander through the terrain of their dispossession, retracing the earlier motions of itinerant labor and also the nomadic lives of pre-European tribes. Theirs is a kind of transformational return.

This is the distilled residue of the regime of the picturesque. Why is so much effort and passion directed toward the erasure of these spaces? Why do we legislate their displacement by treasured emblems of urbanity and countryside and nature? And why, despite these efforts, do such unwanted spaces return and return? Insights about our future stand exposed on the constantly shifting surface of public wilderness. As the frank reality of life and death on such terrain begins to surface in the work of Glenn Rudolph, Michael Brophy, and others, we witness the full double-valence of our entanglement with this troubling regime.

1
Rick Rubin, *Naked Against the Rain: The People of the Lower Columbia River 1770–1830* (Portland: Far Shore Press, 1999), 44.

2
Charles D'Ambrosio, essay in *Michael Brophy: Paintings* (Astoria, Oregon: Clear Cut Press, 2003), 10–11.

3
Diana George and Charles Mudede, "Last Seen" (Vancouver: Artspeak, 2002), section 7.

MATTHEW STADLER is a novelist, literary editor of *Nest*, and the editor of Clear Cut Press. He lives in Astoria, Oregon.

The
Value Village
Manifesto

From the

Office for

Soft Architecture

Our resources seem inadequate. We cannot fix our object. We are anxious and bored and must shop.

Habitually we go to Value Village. Value Village is a thrift department store. The first store in the chain was founded in San Francisco in 1954. Then Value Village spread northwards up the Pacific coast, through Portland, Seattle, and Bellingham to Vancouver. In an amusing reversal of the clichéd movements of culture, it has begun moving east. Its concept remains unique and specific to this West Coast chain. It markets the reusable detritus of material culture in department store settings whose ambiance is determined by modern values of convenience, orderliness, and clarity. Typically Value Village occupies the huge window-walled shell of a disused modern supermarket situated in a generous parking lot. It ranges bulk-purchased items from charity foundations in wide, boulevardesque aisles, under clear, even fluorescent lights, in organized and colour-coded departments staffed copiously by trained, efficiently smocked workers. VV clinically frames the drifting technique common to the international aficionados of junk. It repeats the frame as a product. We borrow it for our stance.

In this manifesto, Value Village supplies us with an economy and with a metaphor—a metaphor indicating a stance towards cultural centrism and its glorious failure.

The rationalist clarity of Value Village differs importantly from the great chaos of the Marchés aux Puces of Clignancourt and Porte de Vanves, the Protestant piety of church sales in Toronto, the claustrophobic domesticity of the London charity shop, the republican cheer of the jumble sales and tag sales of Vermont. The difference is not in the specificity of content: each of these sites yields a picturesque mixture of high and low, of styles and labels and periods, of charmingly regional paraphernalia, a temporary confusion of demotic and avant-garde, a stirring up of contrasts and extremes and origins. Any thrift sale is the potential frame of the found object as autonomous aesthetic trope. Any thrift shopper is a primitive, a maverick. Any thrift shop reminds us of our favourite Joseph Cornell box. But Value Village inflates utopia. Value Village inflates the picturesque. The compelling romance of region cancels itself in an orderly infinitude of repetition. Value Village is big-box thrift, high-concept mass marketing applied to the movement of junk. Value Village knows that far from constituting an authenticity, a boutique, the desire for a demotic picturesque has founded a market that can be regularized and repeated infinitely. This is a sanitary setting for the consumption of our own garbage. It's an ecology of abjection. Value Village saw that shoppers want a clinic. It originated this marketing theory on the West Coast, where stripped of the limit of contextualizing histories of modernity, theories and utopias fast-forward into spectacle. On this coast the spectacle conflates with the spiritual. Utopia demands belief. Insofar as the procedures and rituals of retail marketing supply a spiritual ambiance, a complex imaginary ritualization and decorporealization of consumer desire and habit, we attend VV as we would attend a church. What we seek is not the specificity of an object, but a temporary experience of suspension or spiritual integration within a regularized frame big enough to feel freeing and adventurous, and cheap enough to be infinitely accessible. Value Village markets the failed tropes of capital as an ambiance. It doesn't parody the phantom exclusivity of the consumer fetish—it parodies the iterability of the demotic. Our intrigue with pathos and shame makes us return.

This is the inverse of modernism's economy. Value Village markets a format for the inversion of

utopia. Here the paradise of the department store is turned inside out, to display the city's disjecta, lapses, failures. Here failure becomes an ambiance whose luxury is its spacious, well-lit, clean convenience. The individual melts. If the myth of the frontier allegorizes a heroic advance guard, a paradisial economy of plenty, the demotic accessibility of permeable hierarchies, and the eclipse of old-world static ideologies into a wild plenum of difference and maximum access to means, VV turns anyone into a heroic flaneur. But it does so by recognizing that the stance of the flaneur requires a new frame, a frame that formulaically constructs itself from a portion of remembered shopping ritual—the supermarket or department store—a portion of boredom and anonymity, a portion of desire, and the spiritual aptitude for abjection perfected through serial failure.

We love to stroll there often.

Like a new city, it's laid out on a grid. We enter with the undirected potential of boredom. Here boredom is useful. There is too much surface. Value Village is too big. Too many terrible items are too thoroughly organized. It's quite ugly. All intention is pointless and must be abandoned. Selection takes directions within the departmentalized system without aiming at ends. It begins with passivity. We observe the simultaneous proliferation and cancellation of origins. We submit to louche textiles. We feel disgust, timidity, and glee. It proceeds by dissociation and division. We begin to adapt to a random texture. The adaptation becomes a material movement. We try it for fit. The fibre is stimulating. We're wearing a metaphor, lightly emanating a stranger's scent. It's like a drug. It's departmentalized. It produces experience synthetically. We define spiritual desire thus.

We want an impure image that contradicts fixity. Something deliciously insecure: the sheath of a nerve.

We go to the House of V to encounter the glimmering selvage of the popular, as the popular unravels itself. We handle retrospect labels and fibres. We analyze cut. We study change. We believe that the tactile limits of surfaces mark out potential actions. We excavate a strange jacket from the anonymity of mass memory and slip our arms into the future. It has a name. It seems to look back but in doing so it renovates the gaze. The garment italicizes the body, turns it into speech.

"What's your shirt?"

House of Vitruvius, House of Venus, La Dolce Vita, House of Varda, House of Werther, House of Venturi, House of Vionnet, House of van Brugh, the Velvets, the Viletones, Versailles, Visconti, House of Vorticism, Vivienne Westwood, House of Verlaine, House of Van Noten, House of Vygotsky, House of Vico, House of Vishnu, House of Velasquez, House of Voysey, House of Vreeland, House of Viva, Luxe, Calme et Volupté, House of Wordsworth, House of Versace, the Blessed V, House of Valentino, House of Verdi, Violette Leduc:

We are the Market. We are the Museum. We are the House. Garishly we turn to face you.

This is the revolutionary costume. This is the voluptuous eclipse of historical affect. Our address is superfluous. Then, there is the fluency of crepe de chine, of fine batiste, of crumpled linen, of Dacron, Orlon, and defunct polyesters, of Lamex and Lurex, PVC and good wool twist … The fibrous layers build out and mould our soul. This textile thatching is our practice. This facing is our fabulous task. What garment is adequate? Did we dream that the red pigment from the cloth binding of Carlyle's *Sartor Resartus* had stained our nightreading fingers? Even our pronoun is tailored. A French seam sculpts it. Ergo, clothing is metaphysical. It constitutes the

dialectical seam threading consciousness through perception. Like metaphysics it wears out. We prefer ours secondhand.

At the House of V, modernity greets the rag trade. Here, theories and markets are cheap. Cast-off Being dangles from the racks. Under the harsh, even illumination of fluorescent tubing, all labels and movements converge in a convenient and accessible archive. This is the mirror image of the avant-garde: it recedes from its economy. We finger the bad judgements in mass-market branding; we fraternize with frayed and gaudy trousers as if we remembered them; we mimic the seaminess of markets. We choose among lurid failures. We feel popular. It is always a pleasure.

This is also the school of luck. When faced with the aleatory, we need parameters; we need a house. When we want to research the relation of randomness to the erotic, we stroll here of an afternoon. We glimpse Lady Fortuna slip into a torn fur coat. At the House of V all houses clandestinely meet. The mixed-up day becomes luxurious. We want to use the word cosmos. Strange, necessary answers unspool into visible, tactile life.

The House of V is a combinatory paradise ruled by pathos and grotesquerie. We think it feels gratuitously sexual: each garment describes differently the collapse of the ideal. In long, wide aisles ideal for contemplative promenade, red-smocked workers rank shabby disjecta by gender, age, ethnicity, reproductive status, size, colour, object, and garment type. It's overlaid by a maudlin pop sound track mixed with inspirational shopping aphorisms. We hum along. Here, eroticism is liberated from gravitas. It's the same Value Village in each coastal city. All difference is equivalently accessible because it has been rejected and then rigorously systematized. We only need luck. Like curious gentleman botanists formed by the dialect of our discipline, we drift through a bounded yet open system of kinds.

They buy the big bricks of clothing, bound together. They buy it from charity. Unconscious data. There is always more. Mauve nylons. Car coats. Rickrack. These garments are like lyric structures cast aside. Motley existence has passed through them. Their vulnerability lends us a rhetoric. Our gaze is relaxed and technical. We're not afraid of cliché. In the worn-out, anonymous garment, material sentiment has been liberated from cause. Here sentiment extends enjoyably into the indeterminacy of detritus. Anything is possible. We'll conduct our life unrecognizably. Recombinant figures of memory present themselves. In the House of V we'll untwirl that life. Sociology becomes ornament, like a decorative scarwork. The seam has been caringly mended. The names of lapsed products taunt us.

House of V is the new museum.

Here we luxuriate in the unoriginality of our desires. They are clearly catalogued. Here we can recognize that if the tedium of aesthetic markets constitutes identities, that constitution can be unraveled back to a foundational boredom. The proliferation of failures resides for a moment on that surface. In the tedium we glimpse the new. It is not a style or a content. It is a stance. There is no place but a stance. It accepts all that is defunct, such as Europe and America. It drifts and plays and enunciates and returns, unheroic.

Lisa Robertson writes as the Office for Soft Architecture from Vancouver, British Columbia. A collection of OSA commissions will be published by Clear Cut Press in 2003.

Works in the Exhibition

MICHAEL BROPHY

Forest Room, 1999
Oil on canvas
79" x 93"
Courtesy the artist

The Backroom, 2002
Oil on canvas
79" x 88"
Courtesy the artist

DELIA BROWN

Pastorale, 2002
DVD
Approx. 4 minutes
Courtesy the artist and D'Amelio Terras
Gallery, New York, New York

BRIAN CALVIN

California Freeform, 2000
Acrylic on canvas
60" x 108"
Collection of Marcia Goldenfeld
Maiten and Barry Maiten,
Los Angeles, California

Nowhere Boogie, 2000
Acrylic on canvas
24" x 44"
Courtesy MARC FOXX, Los Angeles,
California

Stream, 2003
Acrylic on canvas
78" x 48"
Collection of Dean Valentine and
Amy Adelson, Los Angeles, California

RUSSELL CROTTY

Milky Way Over Extreme Ponderosa, 2000
Ink and pencil on paper
48" x 48"
Courtesy Shoshana Wayne Gallery, Santa
Monica, California

Beyond the Waking World, 2001
India ink on paper on Lucite
36" diameter
Private collection, Corvallis, Oregon

Touchable Sky Over Oak Woodlands, 2002
Watercolor and ink on paper,
mounted on Lucite
36" diameter
Courtesy Marilyn and Larry Fields

ROMAN DE SALVO

Yesterquest, 2003
Mixed media
Dimensions variable
Courtesy the artist and Quint
Contemporary Art, La Jolla, California

TRISHA DONNELLY

Untitled, 1998–9
DVD
4 minutes, 30 seconds (loop)
Courtesy Casey Kaplan,
New York, New York

Blind Friends, 2000
C-print
11" x 14"
Courtesy Casey Kaplan,
New York, New York

Malibu, 2002
Gelatin silver print
35" x 49"
Collection of Bernardo Nadal Ginard,
Massachusetts

STAN DOUGLAS

Every Building on 100 West Hastings, 2001
Color photograph on photo paper
$47\frac{1}{16}$" x $191\frac{9}{16}$"
Vancouver Art Gallery Acquisition Fund
with the financial assistance of the Louis
Comtois Trust, VAG 2002.9

SAM DURANT

Landscape Art (Emory Douglas), 2002
C-print
50" x 66"
Courtesy the artist and Blum & Poe, Los
Angeles, California

Return, 2002
C-print
40" x 50"
Courtesy the artist and Blum & Poe, Los
Angeles, California

THOMAS EGGERER

Norma, 2001
Acrylic on canvas
49" x 69"
Collection of Dean Valentine and
Amy Adelson, Los Angeles, California

Softball, 2001
Acrylic and pencil on canvas
34" x 40"
Collection of Jill and Dennis Roach

Onward, 2003
Acrylic on paper
63" x 59"
Collection of Rena Conti and Ivan
Moskowitz, Brookline, Massachusetts

KOTA EZAWA

Home Video, 2001
Digital animation
3 minutes (loop)
Courtesy the artist and Haines Gallery,
San Francisco, California

The Simpson Verdict, 2002
Digital animation with audio
3 minutes
Courtesy the artist and Haines Gallery,
San Francisco, California

HARRELL FLETCHER &
MIRANDA JULY

Learning to Love You More
2002–ongoing
Website www.learningtoloveyoumore.com
and resulting completed assignments
Courtesy the artists

EVAN HOLLOWAY

Left-Handed Guitarist, 1998
Foam, paper, plaster, graphite
63" x 62" x 52"
Courtesy the artist and MARC FOXX, Los
Angeles, California

Incense Sculpture, 2001
Incense, plaster, steel, carpet
53" x 30" x 37"
Private collection, courtesy MARC FOXX,
Los Angeles, California

CHRIS JOHANSON

This Temple Called Earth, 2003
Installation: wood, wood shavings, paint
Overall dimensions variable
Courtesy the artist and Jack Hanley
Gallery, San Francisco, California

Six paintings: all acrylic on wood

Man Leaving in Boat
12" x 16"
Collection of Jack Hanley

Single Line of People
15 $\frac{1}{2}$" x 27 $\frac{1}{2}$"
Collection of Sara Ephraim Kier

Single Line of People (large)
41" x 54 $\frac{1}{2}$"
Collection of Jacky Ilana Allalouf

Two Lines of People
12" x 14"
Private collection

Three Lines of People
42" x 54"
Collection of Godfrey McLaughlin

Abstract Conceptual Symbol
52" x 52"
Courtesy the artist and Jack Hanley
Gallery, San Francisco, California

BRIAN JUNGEN

Prototype for New Understanding #2, 1998
Nike Air Jordans, hair
13 $\frac{3}{4}$" x 11 $\frac{13}{16}$" x 11 $\frac{13}{16}$"
Vancouver Art Gallery Acquisition
Fund and purchased with the financial
support of the Canada Council for the
Arts Acquisition Assistance Program,
VAG 99.20.1

Prototype for New Understanding #3
1999
Nike Air Jordans
13 $\frac{3}{4}$" x 11" x 12"
Vancouver Art Gallery Acquisition
Fund, purchased with the financial
support of the Canada Council for the
Arts Acquisition Assistance Program,
VAG 99.20.2

Prototype for New Understanding #12
2002
Nike Air Jordans, hair
26 $\frac{1}{2}$" x 23" x 10"
Collection of William and Ruth True,
Seattle, Washington

Variant #1, 2002
Nike athletic footwear
52" x 45"
Collection of Michael Audain and Yoshiko
Karasawa, Vancouver,
British Columbia

TIM LEE

The Move, The Beastie Boys, 1998
2001
3-channel video installation
4 minutes, 48 seconds
Courtesy the artist and Tracey Lawrence
Gallery, Vancouver,
British Columbia

KEN LUM

Amir New and Used, 2000
Plexiglas, powder-coated lacquered
aluminum, plastic letters, enamel paint
60" x 84"
Courtesy the artist and Andrea Rosen
Gallery, New York, New York

Grace Chung Financial, 2001
Plexiglas, powder-coated lacquered
aluminum, plastic letters, enamel paint
78" x 78"
Courtesy the artist and Andrea Rosen
Gallery, New York, New York

LIZ MAGOR

Hollow, 1998–9
Polymerized alpha gypsum, fabric, foam
41 $\frac{3}{4}$" x 47 $\frac{5}{8}$" x 71 $\frac{5}{8}$"
National Gallery of Canada, Ottawa,
purchased 1999

KD–the Original, 2000
Silicone rubber, food
66 $\frac{1}{8}$" x 14 $\frac{3}{16}$" x 7 $\frac{7}{8}$"
Collection of Kathleen and Laing Brown,
Vancouver, British Columbia

Double Cabinet (blue), 2001
Polymerized gypsum, cans of beer
9 $\frac{7}{16}$" x 27 $\frac{3}{16}$" x 16 $\frac{15}{16}$"
Collection of Christos and Sophie
Dikeakos, Vancouver, British Columbia

MATT McCORMICK

The Subconscious Art of Graffiti Removal,
2002
DVD (projection)
Approx. 16 minutes
Courtesy the artist
(www.rodeofilmco.com)

ROY McMAKIN

Untitled, 2003
Courtesy the artist and Domestic
Furniture
1. Wood bench
Claro walnut, oil, steel
17" x 20" x 66"
2. Wood bench
Big leaf maple, oil, steel
17" x 20" x 66"
3. Wood bench
Oregon white oak, oil, steel
17" x 20" x 66"
4. Wood bench
Eucalyptus, oil, steel
17" x 20" x 66"
5. Wood bench
Elm, oil, steel
17" x 20" x 66"
6. Upside-down bench
Maple, enamel paint
17" x 20" x 66"
7. On-end bench
Maple, enamel paint
66" x 20" x 17"
8. On-wall bench
Maple, enamel paint
66" x 20" x 17"
9. Sloping bench
Maple, enamel paint
66" x 22" x 17 $\frac{3}{4}$"
10. Hanging bench
Maple, enamel paint, steel, rope
23" x 20" x 66"

MARK MUMFORD

Nothing Ever Happened Here, 2002
Vinyl lettering
Dimensions variable
Courtesy the artist and James Harris
Gallery, Seattle, Washington

We Are All in This Together, 2002
Vinyl lettering
Edition 1 of 3
Dimensions variable
Courtesy the artist and James Harris
Gallery, Seattle, Washington

Hold Still, 2003
Digital print
Dimensions variable
Courtesy the artist and James Harris
Gallery, Seattle, Washington

**Shannon Oksanen &
Scott Livingstone**

Vanishing Point, 2001
DVD
Approx. 4 minutes
Courtesy the artists

Michele O'Marah

White Diamonds and Agent Orange, 2001
Two-channel video installation
20 minutes
Courtesy the artist and Mary Goldman
Gallery, Los Angeles, California

Marcos Ramírez ERRE

Crossroads (Tijuana/San Diego), 2003
Aluminum, automotive paint,
wood, vinyl
144" x 40" x 40"
Collection of the Museum of
Contemporary Art San Diego,
museum purchase

Glenn Rudolph

W. R. Duncan in His Garden, Seattle, 1976
(printed 1999)
Four-color carbon transfer
30" x 30"
Courtesy the artist

Security Guard, Stampede Pass, 1998
Gelatin silver print
30" x 40"
Courtesy the artist

Trailer, Stampede Pass, 2000
Gelatin silver print
30" x 40"
Courtesy the artist

Cherry Picker, Priest Rapids, 2001
Inkjet print
30" x 30"
Courtesy the artist

Red Blanket, The Order of the Falcon, Kent,
2001
Inkjet print
30" x 40"
Courtesy the artist

Steven Shearer

Guitar #5, 2002–3
Archival inkjet prints on photo paper, edition of 5
Light jet print
71" x 113"
Courtesy the artist

Catherine Sullivan

Little Hunt, 2002
DVD
15 minutes, 30 seconds
Courtesy the artist and Richard Telles
Fine Art, Los Angeles, California

Larry Sultan

Kitchen Window, Topanga Canyon, 1999
C-print, edition of 10
50" x 60"
Courtesy the artist and Stephen Wirtz
Gallery, San Francisco, California

Suburban Street, West Valley Studio, 1999
40" x 50"
C-print, edition of 10
Courtesy the artist and Stephen Wirtz
Gallery, San Francisco, California

Tasha's Third Film, 1999
C print
50" x 60"
Courtesy the artist and Stephen Wirtz
Gallery, San Francisco, California

Cabana, 2000
C-print, edition of 10
40" x 50"
Courtesy the artist and Stephen Wirtz
Gallery, San Francisco, California

Woman In Garden, 2001
C-print, edition of 10
40" x 50"
Courtesy the artist and Stephen Wirtz
Gallery, San Francisco, California

Ron Terada

Entering City of Vancouver, 2002
Extruded aluminum, diamond-grade
vinyl, lights, galvanized steel, wood
120" x 120" x 60"
Courtesy the artist and Catriona Jeffries
Gallery, Vancouver, British Columbia

Althea Thauberger

Songstress, 2001–2
DVD
29 minutes
Courtesy the artist

Songstresses:
"Reaching Over"
Composed by Katrina Kadoski
Vocals and acoustic guitar:
Katrina Kadoski

"Sunshine"
Composed by Julia Skagfjord
Vocals and acoustic guitar: Julia Skagfjord

"Looking for Something"
Composed by Kathryn Calder
Vocals: Kathryn Calder
Electric guitar: Luke Kozlowski
Bass guitar: Brooke Gallup
Percussion: Caley Campbell

"Denial"
Composed by Gillian Stone
Vocals: Gillian Stone

"Why"
Composed by Marlene Battryn
Vocals and electric guitar:
Marlene Battryn

"Tomorrow"
Composed by Leah Abramson
Vocals and acoustic guitar:
Leah Abramson
Acoustic guitar: Gordon Breckenridge

"Goodbye Love"
Composed by Elise Hall-Meyer
Vocals and acoustic guitar:
Elise Hall-Meyer

"The Journey of Soul"
Composed by Sung Hee Park-Talbot
Vocals and piano:
Sung Hee Park-Talbot
Percussion: Anthony Duke

Torolab

Urban Survival Unit, 2002
Mixed media
Dimensions variable
Courtesy the artists

Yvonne Venegas

Selections from *The Most Beautiful Brides
of Baja California*, 2000–ongoing
Anette y Lizette (Anette and Lizette), 2001
Consuelo, 2001
Encendedor (Lighter), 2001
Erika y sus hijas (Erika and Her
Daughters), 2001
Maribel en su despedida de soltera (Maribel
at Her Bridal Shower), 2001
Todas Listas (All Ready), 2001
Yordana, 2001
Bandera y Veronica (Bandera and
Veronica), 2002
Bolsa de sabritas (Chips Bag), 2002
Erika y amigas (Erika and Friends), 2002
Liza, 2002
Parejas (Couples), 2002
C-prints, 24" x 36" each
Courtesy the artist

PHOTOGRAPHY CREDITS

thisisyourtruedesi

oəsəporəpɐpɹəʌnˌɪsəəˌɪsə